Creative WEDDING ALBUM DESIGN

WITH ADOBE® PHOTOSHOP®

*Step-by-Step Techniques
for Professional
Digital Photographers*

Mark Chen

AMHERST MEDIA, INC. ■ BUFFALO, NY

Dedication

To Olive and Marcia, my unrelenting supporters.

Acknowledgements

Thanks to Janice Geddes, Shauna Couri, Krista Kaulfus, Steve Snyder, Dragos Dorobantu, Angula Malone, Ronald Johnson, Trung Huynh, Graham Feld, Christy Newman, Debbie Medrano, Erik Xydis, Kara Hueni, Matthew Crawford, Rosie Israel, Sonny Preston, Terrhan Dial, Clayton Carnes, Kame Khadivian, and Gigi Arendt, who photographed numerous weddings with/for me. You are my teammates. High fives to all of you.

Thanks to Laura Javier. You are an apprentice who inspires.

Thanks to all my Photoshop students. Some of your eyes twinkle with enlightenment; some of your questions make me look good or bad; some of you fall unconscious, which prompts me to make funnier jokes. All of you make me a better teacher.

View the companion blog to this book at: http://weddingalbumdesign-chen.blogspot.com/
Check out Amherst Media's other blogs at: http://portrait-photographer.blogspot.com/
http://weddingphotographer-amherstmedia.blogspot.com/

All photographs by the author unless otherwise noted.

Published by:
Amherst Media, Inc.
P.O. Box 586
Buffalo, N.Y. 14226
Fax: 716-874-4508
www.AmherstMedia.com

Publisher: Craig Alesse
Senior Editor/Production Manager: Michelle Perkins
Assistant Editor: Barbara A. Lynch-Johnt
Editorial Assistance from: Sally Jarzab, John S. Loder, Carey Anne Maines

ISBN-13: 978-1-58428-261-7
Library of Congress Control Number: 2009903889
Printed in Korea.
10 9 8 7 6 5 4 3 2 1

Table of Contents

PROJECT 3: *The Making of a Bride* .37

COMPLEXITY LEVEL: Low

TECHNIQUES INVOLVED: Soft-Brush Technique, Layer Masking

PROJECT 4: *The Architectural Wonder*46

COMPLEXITY LEVEL: Medium

TECHNIQUES INVOLVED: Selection, Layer Masking, Layer Blending Modes, Adjusting
Brightness with Levels, Color Correction with Levels

PROJECT 7: *Faces on a Cake* .92

COMPLEXITY LEVEL: Medium

TECHNIQUES INVOLVED: Three-Dimensional Visualization, Layer Blending Modes, Layer Masking, Softening Effect Using Smart Filters

PROJECT 8: *Emotions in Motion* .99

COMPLEXITY LEVEL: High

TECHNIQUES INVOLVED: Soft-Brush Technique, Motion Blur Effect, Liquify Filter, Sepia Toning, Selection/Layer Masking Technique

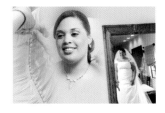

PHOTOGRAPH BY ROSIE ISRAEL.

About the Author

Mark Chen is a photographer, Adobe Certified Photoshop Expert/Instructor, Photoshop trainer, and the owner of Mark Chen Photography based in Houston, Texas.

Chen's passion for photography started early, as a teenager in his native Taiwan. A pursuer of photographic artistry and a believer in imaging technology, Chen embraced digital photography with great enthusiasm. His computer science degree helped him feel at home with digital postproduction. Combining creativity, solid techniques, and a think-outside-the-box attitude, Chen has established himself as a creative wedding photographer whose album designs are sought after by clients with discerning tastes.

In addition to his studio operations, Chen teaches Photoshop at Houston Baptist University and Houston Community College and is touring the nation giving Photoshop training sessions. This teaching experience was an important factor in making this book easy to follow.

Look for information on Mark Chen's workshops and future books about Photoshop and photography, as well as his artistic endeavors that push the limit of what pixels can show us, at www.MarkChenPhotography.com.

Preface

If you were getting married a century ago, the only photos you could get would be shot in a studio. They would probably have been taken on a large view camera. You and your guests would appear stiff because the shutter had to stay open for a while, so the photographer needed everyone to stay still. Consumer cameras, like the Kodak Brownie, were there, but they were no competition for the professional's equipment. If you were a studio owner back then, the business would have been very secure, wouldn't it?

As technology advanced, consumer cameras became easier to use and produced increasingly high-quality images. Soon, the bride's Uncle Bob started to walk up and down the aisle, providing free, amateur photographic services. Uncle Bob might have done a good job, or he might have lost all the shots—either way, business became harder for the studios. Should I move on to the digital era, when you see two-dozen wedding guests photographing with megapixels totalling in the neighborhood of 300? The good old days are gone.

Here is how a studio can survive in the digital era: it needs to do what the consumer can't do. That means a studio needs to have great artistry and technique. The digital technology may have greatly expanded the domain of consumer photography (also known by an even scarier term: "pro-sumer" photography), but it has also broadened the possibilities for professional artists. Among the new possibilities, I would like to talk about the creativity that happens *after* the shutter is clicked: the process known as postproduction.

For nearly twenty years, Photoshop has dominated the market as the industry's standard for digital-image postproduction. This sophisticated program, with its robust-

Readers are encouraged to follow along using practice files that can be downloaded from Amherst Media's web site, at www.AmherstMedia.com/downloads.htm.

ness in image manipulation, is a dream come true for graphic artists.

In this book, I want to show you how Photoshop can be used in creating wedding album pages. The emphasis is creativity. Unlike many Photoshop books in the market that emphasize techniques, teaching Photoshop as if it were Microsoft Office, this book will help you learn technique as a way to create a piece of art. Ten projects of different levels of complexity, encompassing different skill sets, are demonstrated in great detail.

These projects are album pages that can go into so-called "flushmount" albums—that is, albums that do not use mattes. These book-like albums, sometimes referred to as magazine-style albums, have a photo covering the entirety of each page. Whereas some projects are for the album covers, they are mostly cross-page, split-panoramic page designs.

The purpose of this book is to inspire you with creativity and to enable you with techniques. Photoshop CS4 is used in the demonstrations, but most of the techniques introduced are version-independent, so you can follow along even if you are on a different version. While the book title suggests that this is a guide for professionals in the trade, Photoshop users in other fields will find the creativity and techniques universal.

Turning my Houston-based business, Mark Chen Photography (www.MarkChenPhotography.com), into a graphic-design powerhouse is my strategy for success in the 21st century. It could be yours, too. This book will show you what it takes.

Things You Should Know While Using this Book

Instructions

The text in this book is divided into two kinds: explanations and instructions. They are marked with different typefaces, as you can see here:

> These are explanations; read on and think.
> **These are instructions; follow these steps on your computer.**

Collages vs. *Montages*

The works in this book are referred to as either collages or montages. While both indicate a composite of several images, I refer to a montage when the attempt is to create an illusion that these images actually belong to the same imaginary space. The term "collage," on the other hand, does not have this implication.

PC vs. *Mac*

Photoshop users today seem to be equally content on both platforms. Whereas Mac has a longer history and strong foothold in the creative industries, PCs are practical machines that handle a variety of tasks. The Mac and PC commercials from Apple might be biased, but they are rather precise portraits of the two: the former is more fun and the latter is more practical. I am a Mac user, so the screen shots in this book look Mac. It should not be a problem for PC users to ignore the minor differences.

There are more than eight-hundred shortcuts in Photoshop.

Photoshop Versions

While the techniques used in this book are mostly version-independent, differences between CS4, CS3, and the earlier versions of Photoshop are described in detail. If certain interfaces are significantly different in CS4, the CS4 interfaces are presented here.

Shortcuts

There are more than eight-hundred shortcuts in Photoshop. My memory, due to its limited expandability, can't remember a tenth of them. But there is good news for people suffering the same small RAM syndrome—you do not

need to remember them all. My principle is this: if you repeat a certain task three times a day, memorize the shortcut. In the demonstrations in this book, shortcuts are often used. Take my word for it, these are essential ones to learn.

Also, please note that when a shortcut involves a letter, the key is indicated using a capital letter. (This is standard notation for indicating a keystroke, as the letters on keyboards appear as capital letters only.) Unless specifically indicated, do not hit the Shift key. For example, to choose the Brush tool you will be instructed to press B. This simply means press the B key; you should *not* hit Shift+B.

Take my word for it, these are essential ones to learn.

Flushmount Albums

Albums with no mattes (with photographs covering the whole page) are often referred to as flushmount albums, magazine-style albums, or digital albums (the latter is a term I absolutely detest). This is the type of album our page layouts are made for. My studio uses albums made by Graphistudio, based in Italy, and Leathercraftsmen, based in California.

Complexity Levels

Projects in this book have their complexity levels marked as low, medium, or high. This evaluation is related to the number of techniques involved, the difficulty level of using (or understanding) the techniques, and the number of hours required to bring the work to life. While there is no required order in which you should proceed with these projects, it is not a bad idea to start off with the less complex ones.

"What the Wise Man Says"

When you see one of these boxes (the first one appears below), it is basically me whispering into your ear—covering the philosophy, the common sense, the essential knowledge, and the best practices from years of experience as a photographer and a Photoshop professional. You can either read them as guided by the projects or read them as some sort of spiritual experience. In the latter case, I recommend taking this book from the computer and placing it either at your bedside or in the rest room.

WHAT THE WISE MAN SAYS 1

EASE YOUR WAY IN:
USE THE COVER PAGE AS AN APPETIZER

My idea of a cover page is to entice the viewers. It does not have to reveal too much. It can be a "sneak preview," like the image created in this chapter. I do not like a cover page that sums up the whole story, for example, a traditional wedding portrait. That is for our grandmothers' wedding albums.

A Glimpse Into a Dream

COMPLEXITY LEVEL
Low

TECHNIQUES INVOLVED
Adjustment Layers, Layer Masks, Creative Type Effects

This is a project for the cover of a wedding album. Only a single image is used. Starting with a narrative candid shot taken during the wedding ceremony, we will add creative typography and enhancement.

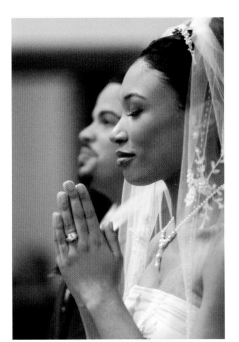

1-1. The original image. Photograph by Dragos Dorobantu.

Prepare the Canvas

The original image is as illustrated in image **1-1**. This superb image was taken from the side of the altar during a Catholic ceremony. At a moment of serene happiness, the bride was praying with a smile. The groom was behind her and out of focus, yet the theme is clear: I am so happy that I am becoming your wife today. To turn this into a dreamy world, emphasizing the bride's inward happiness, I want the surroundings to be de-accentuated, as if they are forgotten. I also want glows around the bride so it looks like the happiness is truly radiating from her.

You can find yourself an image that has a similar atmosphere to try this project. Or, you can download the practice file from Amherst Media's web site (see page 8). (*Note:* These low-resolution files are for on-screen practice only; for prints, you would need files with three times this resolution). Begin by opening the file you select in Photoshop.

Now, we need a canvas for our montage. To create this, go to File > New. Create a file that is 9.5 inches wide and 14 inches high at 100dpi. At Background Content, use the pull-down menu to select Transparent. Type "Dream" in the Name field and click OK.

Press V to activate the Move tool. Click on image **1-1** and drag it into the canvas of Dream. In the Layers palette, double click on the new layer (Layer 1) and rename it "Couple."

The Glow

Controlled Gaussian Blur is commonly used to soften images. However, image sharpness is often compromised in the process. Here is a technique

MEET THE NEW BUGS ON THE BLOCK

Whereas some new features are rather ingenious in Photoshop CS4, some are just annoyance.

Besides the new interface for Adjustment layers (as discussed in What the Wise Man Says 4 on page 17), my favorite new feature is the preview for the Clone Stamp and Healing Brush tools. Those who have been using Vanishing Point in CS3 know that the Clone tool there already offered a preview within the circular cursor. Thankfully, the engineers at Adobe have now adopted this feature for more frequently used tools, as well. Sometimes, we just need to take care of the obscurities before tackling the obvious.

There are, of course, also some new bugs that ruin my day. (These might not be officially recognized as bugs by Adobe, so don't quote me here—and, since I am a Mac person, I have only observed the these phenomena on Macs.)

First, there seem to be some delay in refreshing. This happens when you drag a layer into the canvas of another image. You release the Move tool and nothing happens. Then, when you move the cursor, the dragged-in image starts to appear. This is totally new in CS4. There are even cases when certain changes are not displayed in an image. Then you zoom in or zoom out . . . and there they are.

The number-one annoyance is the tabbed images. When opening multiple images in CS4, they are (by default) opened in a single window with tabs for each image. I simply hate it. We are graphic designers and we need to see the images at a glance—we do not need the nerdy tabs!

You might think that turning this annoyance off in the Preferences resolves the issue—but you're wrong. A totally new phenomenon emerges once the tab feature is turned off. If the top bar of an image is dragged under the Menu/Options bar, it stays *under*. Then, when you are ready to move that image around, you have nowhere to drag it from. If you try this on CS3 (or earlier), you will find the image nicely slips out from beneath the Menu/Options bar.

Why did the Photoshop engineers abandon this nice, little, and *very* useful feature? This question, along with the question of how the universe was born, are now on the top of my "Life's Eternal Puzzles" list.

that will soften without degrading the sharpness. We will limit the softening only to the highlights. In this image, this means the softening will be limited to the veil, the dress, and a small portion of the face. Since the softening is only on the highlights, it will look like a glow.

We will first make a selection of the highlights. A selection based on brightness will be handy—and the Magic Wand comes to mind. In the Tools, activate your Magic Wand tool. The symbol for this is seen in image **1-2**.

1-2. The symbol for the Magic Wand tool.

In the Options (at the top of the screen), make sure you *deselect* Contiguous, as shown in image **1-3**, so the selection will include all of the qualified highlights

Contiguous

1-3. Uncheck the Contiguous box.

Tolerance: 80

1-4. Set the tolerance to 80.

1-5. The selection that was made with the Magic Wand.

in the whole image (not just those areas bordering the area where you click). Set the tolerance setting to 80, as seen in image **1-4**, then click on the bright spot on the dress near her forearm.

You will see a selection like the one in image **1-5**. The selected area consists of all the pixels that fall within 80 gray levels of the clicked spot on the dress. In other words, these are the highlights.

Next hit Ctrl-J (Mac: Cmd-J) to "jump" the selected area out of the Couple layer and place it on a new layer, which will automatically be labeled Layer 1. Double click on Layer 1 to rename it as "Highlights." (*Note:* Jump is a command that

does not even exist in the good old menus. If you are a shortcut hater, it's time to repent and reform!)

In the Layers palette go to the Couple layer and click on the Layer Visibility (eyeball) icon, as seen in image 1-6, to turn it off. This will reveal what the highlights look like (image 1-7). The checkerboard pattern you'll see in the background here indicates transparency. So, the layer called Highlights is a copy of all the highlights from the Couple layer. Now, turn the Couple layer back on by clicking on the eyeball icon again.

1-6. The Layer Visibility (eyeball) icon.

1-7. The highlight areas of the image.

Now we are going to apply Gaussian Blur to the Highlights layer. This will do a few things. First, it will expand the highlights across a larger area, which simulates the diffusion achieved when one looks through a dirty lens. Second, the areas will become blurry, which creates the soft look. Third, the layers will become more transparent, allowing the viewer to actually see through Highlights layer to the Couple layer.

In the Layers palette, make sure the Highlights layer is activated, then go to Filter > Blur > Gaussian Blur. In the Gaussian Blur dialog box, enter 80. Click OK. You will see the highlights glow. However, some detail on her dress will also be lost.

To correct this, we need to reduce the opacity of Highlights layer a bit to reveal the dress details on the underlying Couple layer. In the Layers palette, click to enter a value of 75 percent in the opacity field, as seen in image 1-8. When you're done, the result should look like image 1-9.

1-8. Reducing the layer opacity.

1-9. The resulting glow seen on the image highlights.

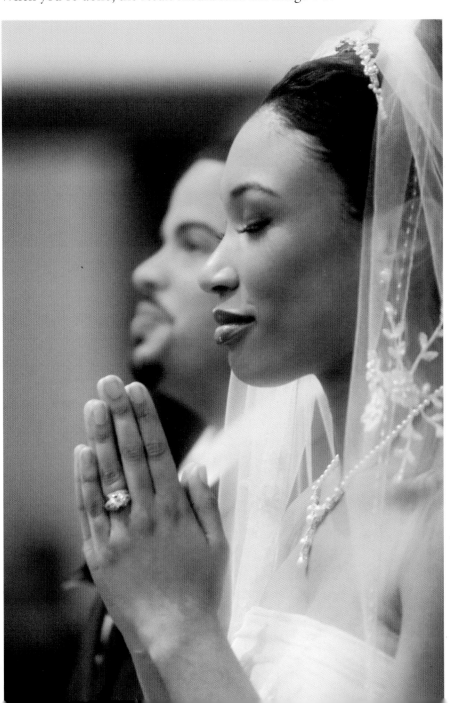

WHAT THE WISE MAN SAYS 3
REGRETTABLE PROCEDURES *VS.* NONDESTRUCTIVE PROCEDURES

Destructive procedures (which I like to call "regrettable procedures," because they give us chances to regret our earlier decisions) can't be undone later if you change your mind. When we do something that we *can* undo and redo later, we are applying a nondestructive procedure (also called a parametric procedure). A few examples of destructive *vs.* nondestructive would be:

DESTRUCTIVE PROCEDURES	NONDESTRUCTIVE PROCEDURES
Using the Eraser tool to remove an unwanted object	Using the Brush to paint black on a Layer Mask to hide an unwanted object
Using the Dodge tool to brighten part of an layer	Using a Levels Adjustment Layer to brighten the layer and a Layer Mask to localize the effect
Using a filter on a layer	Using a Smart Filter on a Smart Object

You will see many examples of nondestructive procedures throughout this book. The geeky term for these is "parametric procedures," which means that the changes are set in parameters, which can be set and reset repetitively.

The question is, why? Just think about how people change their minds. You might change your mind, or the bride might change her mind. The bride might not like a bridesmaid anymore and want her face out of the album. (This is, by the way, a real story!)

The Vignette

The next thing to do is create a vignette. Specifically, we need to darken the areas surrounding the bride's face so she stands out. Later in this project, we will also be adding type to this image, and this darkened background will make the type stand out.

Some people use the Burn tool for this process. While that might achieve what we want here, it is a destructive procedure. Read "What the Wise Man Says 3: Regrettable Procedures *vs.* Nondestructive Procedures" (above) to gain some insights into the important concept of nondestructive procedures. In order to preserve the image, I will use the Levels and a Layer Mask. First, though, let's drop the brightness of the whole image.

In the Layers palette, make sure the Highlights layer (the top layer) is active. Then, click on the Create New Fill or Adjustment Layer icon at the bottom of the Layers palette and choose Levels. In the Levels dialog box, enter 90 for the white point value of the output level, as seen in image **1-10**, and click OK.

In order to preserve the image, I will use the Levels and a Layer Mask.

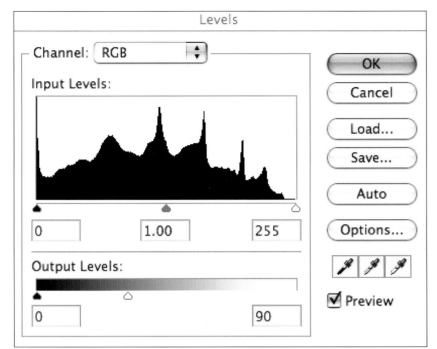
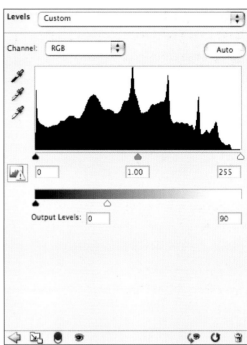

1-10. Adjusting the Levels in CS3 (left) and CS4 (right). See "What the Wise Man Says 4: Changes in the Adjustment Layer Interface."

Now, you will see a rather dark image. Let's use the Layer Mask (one was automatically created with the Adjustment Layer) on the Levels 1 Adjustment Layer to cancel out the effect of the Levels adjustment in the area of the bride.

To begin, activate the Brush tool. In the Options, set the hardness of the brush to 0 percent and the size to 250 pixels. At the bottom of the Tools, set the foreground color to black. In the Layers palette, make sure that the Layer Mask on the Levels 1 Adjustment Layer is activated so that you see a frame around the symbol for the Layer Mask (the white rectangle). Paint black over the area of the

<div style="border:1px solid">

WHAT THE WISE MAN SAYS 4

CHANGES IN THE ADJUSTMENT LAYER INTERFACE

The much anticipated Photoshop CS4 came to us in October 2008. There are quite a few changes from CS3 to CS4; most are for the better, some are for the worse. We will start with one that is on the brighter side of the spectrum.

The interfaces of the Adjustment Layers are now palettes instead of dialog boxes. This new arrangement makes the adjustment available to us on full-time basis, which saves us a few clicks and keeps things more orderly. Two thumbs up on this change!

The new Adjustments palette can be arranged and positioned like all the other palettes. You can choose to have the standard view or the expanded view by clicking on the pull-down at the top-right corner of the palette; this will affect the size of the palette. Larger is better—if you can nicely place it in the corner of a 30-inch monitor. For those of us who do not experience their Photoshop on a cinematic scale, keep it in the standard view.

</div>

bride's face. As you do so, the darkening effect of the Adjustment Layer will be masked out, revealing the desired lighter tonalities on the underlying layer. Leaving the edges of the image unmasked is what creates the dark vignette.

When you're done, you will see something that looks like image **1-11**. Now, the surroundings are nicely darkened with a subtle dropout from the subjects. To see the Layer Mask of the Levels 1 layer, Alt-click (Mac: Opt-click) on the Layer Mask symbol on Levels 1 Adjustment Layer in the Layers palette. The Layer Mask of the Levels 1 Adjustment Layer would look like image **1-12**.

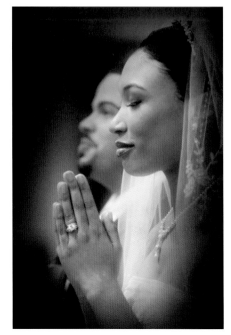

1-11. The vignetted image.

1-12. The Layer Mask on the Levels 1 Adjustment Layer.

The Titles

Next, we will add the titles. Here, I am using a font that was purchased from www.myfonts.com. Feel free to use your own favorite. The font I selected is called Stylor; it's a modern-looking font with thin strokes.

Activate the Type tool. In the Options, select the desired font and set the alignment to center. Set type color to white. Then, click on a spot on the top-left area of the collage. With the caps locks on, type the name of the bride, entering one letter at a time with each followed by the Enter key. When you finish typing her name, press Ctrl-Enter (Mac: Cmd-Return) to accept the typing.

Next, direct your attention to the Layers palette, where you will see a new layer with a T symbol. This is a Type Layer. You might need to adjust the space between the lines (which, in this case, is the space between the characters). To do that, choose the Type tool and select the text by clicking and dragging over it. Then, bring up the Paragraph palette and change the spacing as needed.

Repeat this process with groom's name. At the end, the groom's name will be on a separate Type Layer. Arrange the positions of the bride's and groom's names with Move tool. I like to have them overlapped a bit to give it a sense of depth.

I never liked solid-colored text. To make the text mellow, we can simply reduce the opacity of the Type Layers. This is done at the top of the Layers palette; simply activate the desired layer and adjust the opacity setting. In this case, I used an opacity setting of 75 percent for the bride's name and 40 percent

To make the text mellow, we can simply reduce the opacity of the Type Layers.

for the groom's name. Doing this makes the text semitransparent so that it blends better into the surroundings.

Text Glow

Allowing the text to blend into the surroundings like this, however, somehow compromises its gripping power. Adding an outer glow to the text would be a subtle way to support and emphasize it.

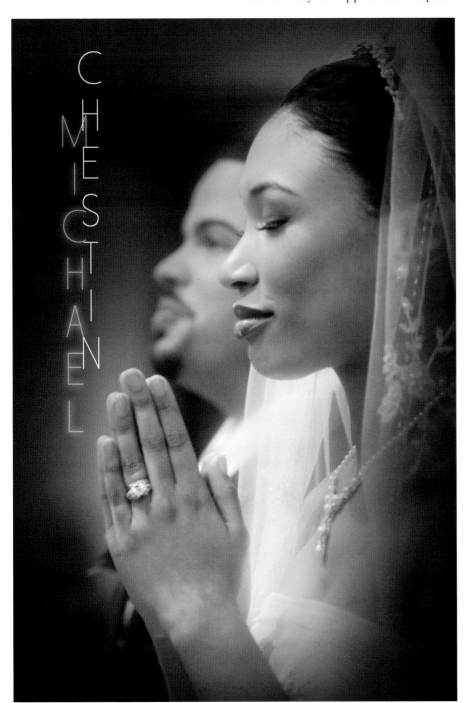

With one of the two Type Layers selected, add a Layer Style by clicking on the "fx" icon at the bottom of the Layers palette and choosing Outer Glow from the drop-down menu. In the Outer Glow dialog box, set the opacity to 100 percent, the color of the glow to white, the spread to 0 percent, and the size to 8 pixels. Then, click OK. (*Note:* These settings for the Outer Glow can be adjusted to your taste.)

In the Layers palette, right click (Mac: Ctrl-click) on the current Type Layer and choose Copy Layer Style. Select the other Type Layer, then right click (Mac: Ctrl-click) on it and choose Paste Layer Style. This is a good way to apply the same Layer Style to multiple layers.

The Results

We have completed the collage. See image **1-13** for the final result.

1-13. The finished look of A Glimpse into a Dream.

A Cosmic Journey

COMPLEXITY LEVEL
High

TECHNIQUES INVOLVED
Selections/Layer Masks, Channel-Selection Conversion, Transform/Warp, Filter Effects, Adjustment Layers

Faces allow us to identify each other and communicate. This is why when you flip through a wedding album you see faces on every single page. However, faces are not the only subjects for a creative album designer to rely on. In this project, I am going to show you a montage that is free from faces—or at least realistic-looking faces.

Couples invest a lot of money and effort in making their weddings memorable—often in some very special ways. There may be fancy cakes, napkins with a logo, live performances, decorations, and much more. It is important for the photographer to notice, capture, and present them in the album. I see this as teamwork between the wedding couple and the photographer (read "What the Wise Man Says 5: You and Your Client as a Creative Team" for more on this [below]).

The following project is a perfect example of riding on the client's creativity. We will be using images of the cake, jelly beans (as party treats), a caricature of the couple that was sketched by an artist during the reception, a shot of the couple holding hands, a laser hologram, and an image of the Andromeda galaxy. These are seen in images **2-1** to **2-6**. If you want to follow along, download the practice files that are available on Amherst Media's web site (see page 8).

Faces are not the only subjects for a creative album designer to rely on.

WHAT THE WISE MAN SAYS 5	YOU AND YOUR CLIENT AS A CREATIVE TEAM

Once in a while, you'll have clients with brilliant ideas and good taste. They will devote extra resources to make their wedding special. The extra touches might be a specially designed cake, wine bottles with customized labels, ceremonies reflecting their ethnic heritage, etc. When you see these things, shoot them. Make it a continuation of a creative process. The clients will be happy that their efforts were documented, and your album will look great.

2-1 to 2-6. The images used to create Cosmic Journey.

2-7. Check this option so all the windows will be zoomed together.

Prepare the Canvas

Open the practice files, then go to Window > Arrange > Tile Horizontally (or in CS4, simply Tile) so you can see all the images. Press Z to go to the Zoom tool, then check Zoom All Windows in the Options, as seen in image 2-7. Move your cursor to the active image, then press and hold Alt (Mac: Opt) and click on the image to zoom out until all of the images are completely visible in their windows. (The Zoom All Windows option was a prayer answered in CS3.)

Now we need a canvas. Go to File > New to create a canvas for our montage. Make it 20 inches wide and 13.5 inches high at 100dpi. Type "Cosmic Montage" in the Name field. Click OK. Again, this resolution setting is good only for the purposes of practicing these techniques. For actual printing, you would need a much higher resolution.

We will want a black background to suit our cosmic theme. If black is not the foreground color, hit D to reset the foreground/background colors to their defaults (black as the foreground and white as the background). Then, hit Alt-Backspace (Mac: Opt-Delete) to fill the current layer (in this case, the background layer) with the current foreground color (in this case, black).

The Galactic Hands

We will use the holding-hands image as the focal center. Using a Layer Mask, these hands will be given a look of astrological mystery.

Press V to activate the Move tool. Click on the hands image to activate it and drag it into the Cosmic Montage canvas. In the Layers palette, double-click on the new layer's name and rename it "Hands."

Hit Ctrl-T (Mac: Cmd-T) to Free Transform the new Hands layer. Press and hold Shift to constrain the ratio of width to height (*i.e.,* to avoid distorting the image), then click and drag a corner handle on the layer, enlarging the image to make it as wide as the whole canvas. Hit Enter to accept the transform.

Next, let's convert the Hands layer to black & white. (And no, you are not going to do Image > Mode > Grayscale. Doing that throws away all the color data, making it a very destructive process. See "What the Wise Man Says 3: Regrettable Procedures *vs.* Nondestructive Procedures" [page 16] for more on nondestructive procedures.) With the Hands layer active, click on the Create New Fill or Adjustment Layer icon at the bottom of the Layers palette and choose Channel Mixer. Check the Monochrome box to turn the image to black & white—but do not click OK yet. You will see that the default black & white recipe is 40 percent red, 40 percent green, and 20 percent blue. You may want try a different combination (just make sure the three channels add up to 100 percent). Watch the changes as you make adjustments.

For this layout, I want the hands to look as bright as possible. Increasing the red channel would produce the palest skin tone on Caucasian skin. (You might not see their faces, but take my word for it, they are Caucasian.) There-

Doing that throws away all the color data, making it a very destructive process.

2-8. *Turning an image to black & white using the Channel Mixer with the red channel at 100 percent. The left image shows the CS3 (and earlier) dialog box. The right image shows the CS4 (and later) Adjustments palette.*

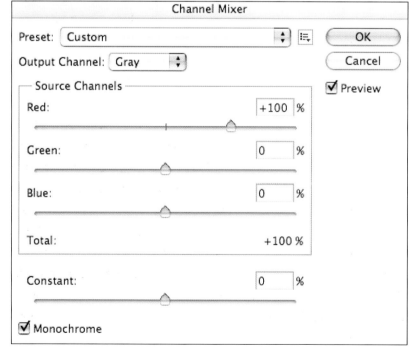

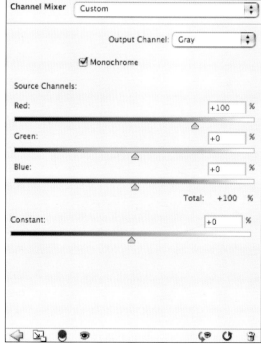

fore, I chose settings of 100 percent red, 0 percent green, and 0 percent blue, as seen in image **2-8**. (If you are using CS3, click OK to accept these settings in the Channel Mixer dialog box. For CS4 users, you'll be using the Channel Mixer palette, which can just remain open while you move on to the next steps; see "What the Wise Man Says 4" on page 17.)

Having made this adjustment, your montage should look like image **2-9**.

2-9. The montage so far, with the Hands layer converted to black & white.

So, why didn't we use a Black and White Adjustment Layer? In my opinion, it is a case of too many choices. Considering all the possible combinations, using CMY and RGB to make black & white is like having too many flavors to choose from at an ice cream parlor. The Black & White Adjustment Layer feature was added in CS3—and, no, you do not have to use all the new features. You don't even have to like them.

Now, let's move on to bring in the image of the galaxy. Press V to activate the Move tool. Drag the galaxy image into the Cosmic Montage canvas, and re-name the new layer "Galaxy."

Hit Ctrl-T (Mac: Cmd-T) to Free Transform the Galaxy layer. Press and hold the Shift key to constrain the aspect ratio, then click and drag one of the corner handles out to enlarge the layer until the Galaxy layer is as big as the canvas. If necessary, let go of the corner handle and drag the layer to reposition it.

Let's also rotate the galaxy so its angle is about the same as that of the hands.

The goal here is to position the galaxy in proximity to the hands. Let's also rotate the galaxy so its angle is about the same as that of the hands. With the Free Transform still active, move the cursor slightly outside of any of the four corner handles. When you do so, the cursor will change into a curved double arrow. You are ready to rotate—just click and drag until the galaxy image is at about the same angle as the image of the hands. When you're ready, hit Enter to apply the Free Transform.

The fact is that we will eventually turn off the visibility of the Galaxy layer. First, though, we will create a Layer Mask from a channel of the Galaxy layer. Let's examine the channels. To do this, bring the Channels palette into view by clicking on its tab. If it's not visible, go to Window > Channels.

Examine the red, green, and blue channels by clicking on the respective channels one at a time. You will see that the galaxy image has a different look in each channel. The red channel is the brightest, while the blue channel has the highest contrast. I love the beautiful details in the blue channel, so let's use that for our Layer Mask. In the Channels palette, select the blue channel by clicking on it. Your galaxy should look like image **2-10**.

Next, go down to the bottom of the Channels palette and click on the button for Load Channel as Selection. Wow! Are we really seeing twinkling stars? Actually, these are the "marching ants" of the active selection indicator. The selection might not seem to cover all the lighter area, but that's because it only shows the cutoff at the midtone. The degree of selection is actually based on the grayscale of the black & white galaxy image.

Go to the Layers palette and turn off the Galaxy layer by clicking on the eyeball icon.

2-10. *The blue channel of the galaxy image.*

2-11. *The Galaxy image converted to a selection on top of the Hands layer.*

Now, the galaxy selection will appear above the Hands, as seen in image **2-11**. We will turn this selection into a Layer Mask for the Hands layer.

In the Layers palette, click on the Hands layer to activate it. Click on the Add Layer Mask icon at the bottom of the Layers palette. We now see the hands through the galactic Layer Mask. They have turned into celestial objects!

To fine tune it, we might want to reposition the hands and the Layer Mask separately. On the Hands layer, click on the Link icon (between the image thumbnail and the Layer Mask icon) to turn off the link, as seen in image **2-12**. Reposition their relative locations by activating either the thumbnail or the Layer Mask and dragging them around with the Move tool.

2-12. *Unlink the Layer Mask and the image in the Hands layer.*

SELECTIONS *VS.* LAYER MASKS

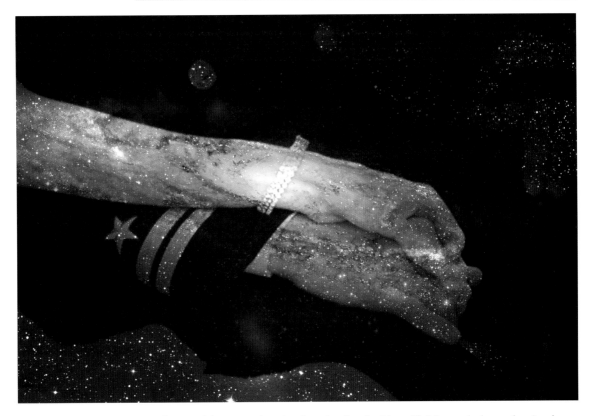

2-13. This is our progress so far, with the hands and galaxy in place.

The goal is to make the hands clearly identifiable and the galactic shape prominent. The core of the galaxy should coincide with her bracelet so it can be highlighted. I would be satisfied with a look like that seen in image **2-13**. Make sure the whole canvas is covered with this starry image. If you have missed some spots, Free Transform the Hands layer to cover the canvas completely.

The Ninth Planet Reinstated

Now that we have a celestial backdrop, let's place the planet. Poor Pluto was disqualified as a planet, but I have a substitute for it: a purple cake.

If you do not have the Rulers activated in the Cosmic Montage canvas, do so by hitting the shortcut: Ctrl-R (Mac: Cmd-R). Rulers are handy for placement.

Now, activate the Move tool and drag the cake image into Cosmic Montage. Rename this new layer "Cake." Press Ctrl-T (Mac: Cmd-T) to Free Transform the Cake layer to make the radius of the cake about 4 inches. Then, use the Move tool to place the cake at the top left corner of the canvas. Place the top edge of the cake image at the top edge of the canvas, and let its left edge fall a quarter of the way off the edge of the canvas.

We now need to select the cake and make a Layer Mask to hide the unwanted background around it. For a round cake, what would be a better selection tool than the Elliptical Marquee tool? However, without help, you might find it frustrating to place the Marquee precisely on the edge of the cake. Try it before you follow the next steps and you'll see what I'm talking about.

Click and drag a horizontal guide out of the top Ruler. Place it at the spot where it intersects the lowest edge of the cake. Leave those "pearls" alone; we will deal with them later. Repeat the procedure to create another guide that is vertical and intersects the right edge of the cake. With the guides in place, your screen should look like image 2-14.

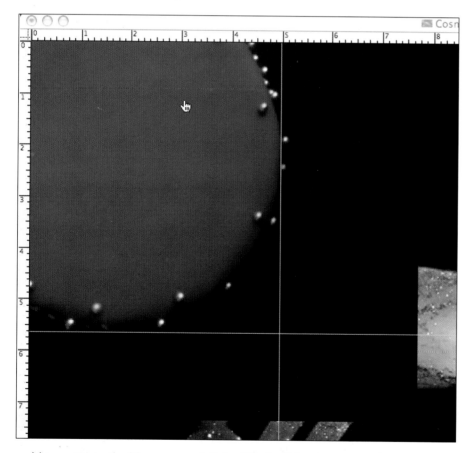

2-14. Two guides are in place to help in placing the Elliptical Marquee.

Now, activate the Marquee tool. If the Elliptical Marquee is not the current selection, click and hold on the Marquee tool icon in the Tools until the Elliptical Marquee appears in the pull-down. Click on it to activate it.

Click and hold at the intersection of the two guides you have just created. Then, drag the cursor up and to the left until the curve of the selection matches the cake's perimeter. (Again, ignore the "pearls.") Release the click. This technique for using guides to place the Elliptical Marquee is essential. Without it, placing your selection at just the right spot can be tricky.

Now we have a selection of the cake, but we are not ready to make a Layer Mask out of it yet. We need to refine the edge of the selection first.

WHAT THE WISE MAN SAYS 7

THE FUZZY REALITY

When selecting an image out of its original background, we have to refine the selection with two basic steps: contract and feather.

The reason that we need to feather the selection is because *all images are fuzzy*. Find the sharpest image that you have ever shot and zoom all the way in to see details. You will see fuzziness. Have a look at image **2-15**. This is an image of a bride in focus, and it looks reasonable sharp. Still, when we zoom all the way in to the pearl necklace, you will see something like image **2-16**. Between the pixels that are clearly defining the pearl or the skin, there are some "transitional pixels" that are a mixture of the pearl and the skin. This is the fuzziness to which I am referring.

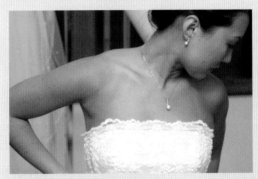

2-15 (left). This bridal portrait is sharp when viewed as a whole. 2-16 (right). When enlarged, transitional pixels ("fuzziness") become visible—such as between the the pearls and the skin.

This fuzziness needs to be reproduced on our selected object. Feathering will simulate this fuzziness by producing a few pixels of transition between the "selected" and the "unselected."

Here comes the problem: the feathering goes in both directions, in and out from the selection. The outward feathering will select areas that are part of the unwanted background. This will resulted in a halo (called fringe) around the object. In order to avoid this, we need to contract the selection. By contracting the selection a few pixels inward, we can avoid having any of the unwanted background "leak" into our selection.

The interactive Refine Edge dialog box, first available in Photoshop CS3, is useful for this process. Now our lives are easier.

If you were too lazy to read "What the Wise Man Says 7: The Fuzzy Reality" (previous page), you'd better stop and read it before you go on to the next step. You have to know *why* we are doing the following steps, or you might just scratch your head and feel puzzled.

With your Cake selection still active, go to Select > Refine Edge. In the Refine Edge dialog box, click the On Black icon at the bottom center to view the selection preview against a black background. Try different settings for Feather and Contract/Expand (keep all the other settings at 0). Finally, set Feather to 2 pixels and Contract/Expand to –50 percent and click OK.

Choosing the –50 percent setting for Contract/Expand, shrinks the selection by 50 percent of the current Feather setting. After this procedure, you might not see too much difference in the selection indicator (the marching ants), but if you understand the "Fuzzy Reality," you'll know that this procedure is required to produce a realistic-looking edge on the selected object.

Now that we have good selection of the purple cake, let's get rid of the background. With the Cake layer selected, click on the Add Layer Mask icon at the bottom of the Layers palette. With that, the area around the cake is gone.

We need to get some of the pearls back, though. We can do that by painting with white on the Layer Mask of the Cake layer. But we can't see where they are—how do we paint in the right spot? The answer is to make a semi-transparent layer. In the Layers palette, drag the Cake layer down onto the Create a New Layer icon. An identical copy of the Cake layer will be created on top of the original Cake layer.

Next, right click on the Layer Mask of the Cake Copy layer and choose Disable Layer Mask. At the top right corner of the Layers palette, turn the opacity of the Cake Copy layer down to 25 percent. Now you can see where the pearls are. We will paint the Layer Mask of the original Cake layer to get them back.

To begin, activate the Brush tool by pressing B. Press Shift-[to turn the Hardness of the brush all the way down to 0 percent. Then, press [or] to adjust the brush diameter until it is about the same size as the pearls, which is about 30 pixels. Set the foreground color to white and, in the Options, make sure the opacity and flow are set to 100 percent.

In the Layers palette, click on the Layer Mask for the original Cake layer (not the Cake Copy layer) to activate it. In the image, paint on each lost pearl with a single click, as seen in image **2-17**.

After all the pearls are regained, return to the Layers palette and drag the Cake Copy layer onto the Delete Layer icon (the trash can) at the bottom of the palette. The Cake copy can be retired now that it has accomplished its mission as a locator. This semitransparent layer technique is very useful in locating otherwise hard-to-find objects.

Now your montage should look like image **2-18**.

This procedure is required to produce a realistic-looking edge on the selected object.

2-17. *Painting the pearls back on the Layer Mask with Brush tool.*

2-18. Cosmic Journey *with the purple planet in place.*

Comet Jelly Beans

Now we will turn the jelly-bean party treats into a comet. Using the Move tool, drag the jelly-bean image into the canvas. Rename the new layer "Jelly Beans."

Use the Magnetic Lasso tool to trace the outer edge of the jelly-bean cluster. When you get to the bottom edge of the image, skip the jelly beans that fall partially outside of the image. Only trace jelly beans that are complete. When you're done, the selection will look like image **2-19**. (*Note:* Read "What the Wise Man Says 8: The Magnificent Magnetic Lasso" [next page] for some tips on using this versatile tool.)

2-19. The jelly-bean cluster is selected.

THE MAGNIFICENT MAGNETIC LASSO

The Magnetic Lasso is my most frequently used selection tool—but like a sharp knife, it can leave you bleeding if you do not use it correctly. The following are a few tips for using it.

First, the anchor points are placed automatically. However, there are two occasions when you want to force anchor points. One is when you need to make a sharp turn. The other is when the Magnetic Lasso is distracted by a nearby border with more contrast that you do *not* want to trace.

Second, when you make a boo-boo, don't cry. Just hit Backspace (Mac: Delete) to cancel anchor points one at a time.

Third, it helps to zoom in reasonably to do the work. Being zoomed far out or zoomed all the way in are both bad for using the Magnetic Lasso.

Finally, when you run out of room (*i.e.,* your cursor is approaching the edge of the window), press and hold the Space bar to pan the canvas. Don't attempt to use the scroll bar or to edge close to the window to let it automatically pan—disasters await! When the panning is done, release Space bar to return to the Magnetic Lasso.

With your jelly-bean selection active, go to Selection > Refine Edge. Use the same settings as we did for the Cake layer, except change the Feather setting to 0.8 pixels. In the Layers palette, click on Add Layer Mask. Then, Free Transform the Jelly Beans layer to make the cluster about 3 inches in diameter. The jelly beans are now an isolated cluster floating in space.

Next, we will isolate a few jelly beans to create the impression that some of them are peeling off as the jelly-bean comet is bombard by cosmic rays. Begin by using the Magnetic Lasso tool to select a jelly bean. Then, apply the same Selection > Refine Edge settings as in the last step. Press Ctrl-J (Mac: Cmd-J) to Jump the selected jelly bean into a new layer. Use the Move tool to drag the detached jelly bean out of the comet—up and to the right, as seen in image 2-20. Repeat the procedure a couple more times on other jelly beans. Keep the detached jelly beans randomly scattered to the top right side of the comet.

Now we need to add a tail to the comet. In the Layers palette, multi-select the Jelly Beans layer and the detached individual jelly-bean layers by Ctrl-clicking (Mac: Cmd-clicking) the layers one at a time. In the canvas, drag the them all to the center of the canvas. We need room for the next procedure.

In the Layers palette, maintain the multi-selection of the layers and drag them all down onto the Create New Layer icon at the bottom of the palette. This will duplicate all the layers—and, now, the duplicated layers will be active.

In the Layers palette, still keeping the multi-selection active but now on the newly created layers, right click on any of the active layers and choose Merge Lay-

2-20. Move the individual jelly beans out of the cluster.

ers. Rename the merged layer "Comet Tail." The Comet Tail layer is a merged layer created from all the jelly beans.

Next, go to Filter > Blur > Motion Blur. In the Gaussian Blur dialog box, set the angle to 30 and the distance to the maximum—999 pixels. Use the Move tool to drag the Comet Tail layer so that its left lower end rests on the Jelly Bean layers. In the Layers palette, press Shift and click on the Jelly Beans layer so that both the Jelly Beans and the Comet Tail layers are selected. Use the Move tool to move both layers so the jelly-beans cluster rests around the lower left corner of the canvas.

What we have created here is a track of the jelly-beans cluster on a separate layer.

What we have created here is a track of the jelly-beans cluster on a separate layer. The reason why we need to do it at the center of the canvas is to avoid the motion blur being truncated by the edge of the canvas.

Now our jelly-beans comet has a tail, but it is too straight. Should we warp it a bit? With the Comet Tail layer selected in the Layers palette, hit Ctrl-T (Mac: Cmd-T) to Free Transform the layer. Right click on the comet tail to show the menu and choose Warp. Drag and pull inside the frame to bend the shape of the comet tail. Make it smaller and curvy at the end. Keep the tail near the jelly beans at about the same width as the jelly-bean cluster. When you're done, the frame should look like image **2-21**. The Warp is a great way to manipulate an image, but it's rather tricky. "Practice makes perfect" is a good motto for Photoshop users, so play with it.

2-21. Warping the comet tail.

Let's add a glow so it looks more like a comet. In the Layers palette, select the Jelly Beans layer. At the bottom of the palette, click on the Add a Layer Style icon and choose Outer Glow. Set the opacity to 40 percent and the size to 24 pixels. Accept all the other defaults, then click OK. (*Note:* This happens to be a rare case in which I would accept the default yellow color for an Outer Glow.)

In the Layers palette, right click on the Jelly Beans layer and choose Copy Layer Style. Multi-select all of the detached jelly-bean layers, then right click on one of them and choose Paste Layer Style. The jelly-bean cluster now glows like a comet. The montage should look like image **2-22**.

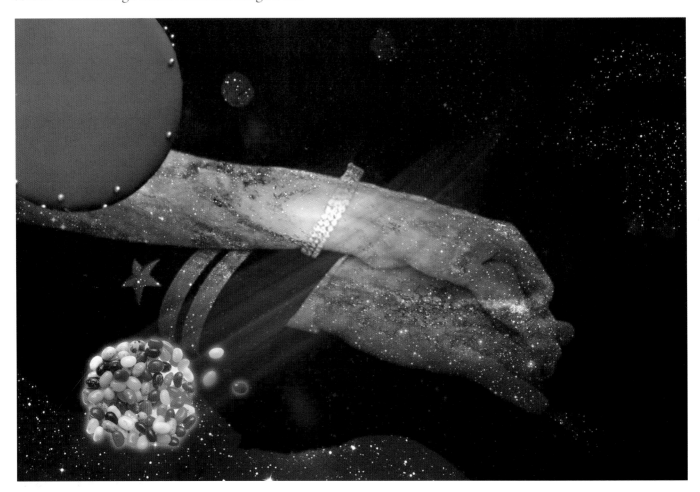

2-22. Cosmic Journey *with the jelly-bean comet in place.*

The N Satellite

The next thing to do is to bring in the laser hologram of the groom's last initial, N. It was illuminated with a light from underneath, which gave a nice glow against a dark background. It's pretty compatible with our outer-space theme.

With the Move tool, drag the image into the canvas and rename the new layer "N." Free Transform it to make the N about 4 inches high, then rotate it clockwise so the N is tilted to the right about 45 degrees.

We will now make a selection of the stylish N. This N is very sharp and has very high contrast against its surroundings. Therefore, the Magic Wand comes to mind.

Press W to activate the Magic Wand, or select it from the Tools (if the Magic Wand is not the current tool, click and hold the Quick Selection tool to reveal the Magic Wand in the pull-down menu). In the Options, set the tolerance to 80.

Make sure Anti-alias and Contiguous are checked. Sample All Layers should be unchecked.

Click on the very center of the N. There will be missing spots on the left side of the letter. Press and hold Shift to add to the selection, then click on these two missing spots, as seen in image **2-23**.

2-23. Three clicks with the Magic Wand are needed to select the N.

It is very important to use the settings indicated above. Using a tolerance setting of 80 gives enough range to select most of the letter without selecting the unwanted areas. Checking the Contiguous box ensures that bright spots not connected to the letter N are not selected. Unchecking the Sample All Layers box leaves the other layers out of this selection business. (*Note:* Your initial Magic Wand selection might look a little different than the screen shots here. As long as you end up with the whole letter N selected, though, you are in good shape.)

With the N selected, go to Select > Refine Edge. Adjust the Feather setting to 1.5 pixels and the Contract/Expand setting to 50 percent. In the Layers palette, click on the Add Layer Mask icon to create a Layer Mask for the N layer. Now, we have a floating N in the space.

Let's give it some motion blur so it seems to fly across the universe. (Hum that Beatles' song while you do the next step, would you?) In the Layers palette, drag the N layer onto the Create a New Layer icon to make a duplicate of it. Rename it "N Track." Drag and throw away the Layer Mask on the N Track layer. When prompted, click Apply. Having done this, the Layer Mask is thrown away, but the effect of the Layer Mask remains.

Go to Filter > Blur > Motion Blur. In the Motion Blur dialog box, set the angle to 30 degrees and the distance to 200 pixels. Click OK. Activate the Move tool and move the N Track layer to the left so that its right end rests directly on the N.

The reason we had to throw away the Layer Mask for the N Track layer, before we applied the Motion Blur filter, is that when the Layer Mask is mixed into the Motion Blur, it tends to get too blurry and make the image less sharp. Applying the Layer Mask first, leaving a clean-cut image, and then applying the motion blur will make everything look more crisp.

At this point, your montage should look like image **2-24** (next page).

The Layer Mask is thrown away, but the effect of the Layer Mask remains.

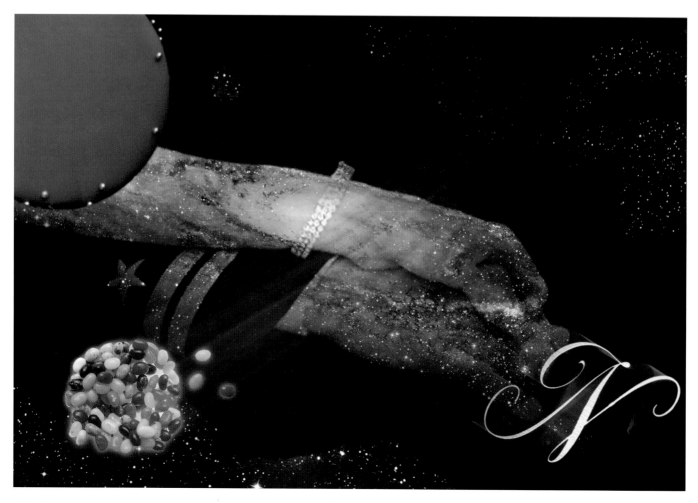

The Caricature Gemini

Next, we will put the drawing of the newlyweds in the starry sky. We will first, however, invert it to create a negative image, so the paper will be dark and the strokes bright.

Use the Move tool to drag the caricature image into the canvas. Rename this layer "Faces." Move and Free Transform the Faces layer until the faces are about 4 inches tall (and the artist's right hand and pen fall out of the canvas).

With the Faces layer selected in the Layers palette, click on the Create New Fill or Adjustment Layer icon and choose Channel Mixer. In Channel Mixer dialog box, check Monochrome. Set the red channel to 100 percent and set the other channels at 0 percent. This produces the most contrast on this image.

In the Layers palette, click again on the Create New Fill or Adjustment Layer icon. This time, choose Inverse.

Press and hold Alt (Mac: Opt) and move the cursor into the Layers palette between the Faces layers and the Channel Mixer layer above it. You will see a different cursor that looks like two overlapping circles. Click to clip the Channel Mixer layer to the Faces layer. Do the same to the Invert layer, making it clip to the Channel Mixer layer (and, hence, to the Faces layer). Now the Channel Mixer

2-24. Cosmic Journey *with the Satellite N in place.*

Next, we will put the drawing of the newlyweds in the starry sky.

2-25. The Invert and Channel Mixer layers are clipped to the Faces layer.

and Inverse layers both have an arrow symbol in front of them, as seen in image 2-25. This indicates that they are clipped to the Faces layer. This is an important trick to apply the effect to only the layer directly under it.

Next, we want to get rid of the frames and the left hand of the artist, so the faces will be free from recognizable traces of human civilization. We will use a skill that I refer to as the soft-brush technique.

In the Layers palette, select the Faces layer and click on the Add Layer Mask icon at the bottom. Our next step is to fill the Layer Mask with black. Check the bottom of the Tools to see if your foreground is black. If it is, hit Alt-Backspace (Mac: Opt-Delete) to fill it to the current layer (or Layer Mask). If the background color is black, hit Ctrl-Backspace (Mac: Cmd-Delete) to fill black to the current layer (or Layer Mask).

Press B to activate the Brush tool. Set the foreground color to white, the brush diameter to about 250 pixels, and the hardness to 0 percent. Making sure the Layer Mask on the Faces layer is selected, paint on the area where the faces are to bring them back without revealing the hand or the frame of the drawing. If the unwanted objects are accidentally revealed, press X to swap the foreground color to black and paint them back out.

Using the Brush tool to paint a very subtle dropout on a Layer Mask is an essential skill for bringing a soft look to a collage. It hides the edgy look and makes the collage more fluid and organic. Read "What the Wise Man Says 9: Brushes are Your Friends" (below) and "What the Wise Man Says 20: A Soft

WHAT THE WISE MAN SAYS 9
BRUSHES ARE YOUR FRIENDS

Brushing on the Layer Mask is a flexible way to manipulate images. By switching between black and white paints you can hide or show areas of the image at will. The following are a few tips for using brushes.

First, use shortcuts. Hit [to reduce the brush diameter or] to increase it. Press Shift-[to reduce hardness or Shift-] to increase it. Press D to restore the default foreground/background colors (black as the foreground, white as the background). Hit X to swap the foreground/background colors.

To paint soft dropouts, start by using black paint to hide the edges. Alternately, you can "disappear" the whole image first by filling the Layer Mask with black. Then, bring areas back selectively by using white paint on the Layer Mask.

When you overpaint, say "Oops!" and press X to swap to the opposite color. Then paint with the color to fix the problem.

This is a highly nondestructive procedure that allows you to refine or adjust your results an infinite number of times. Why would you ever want to use the Eraser tool again?

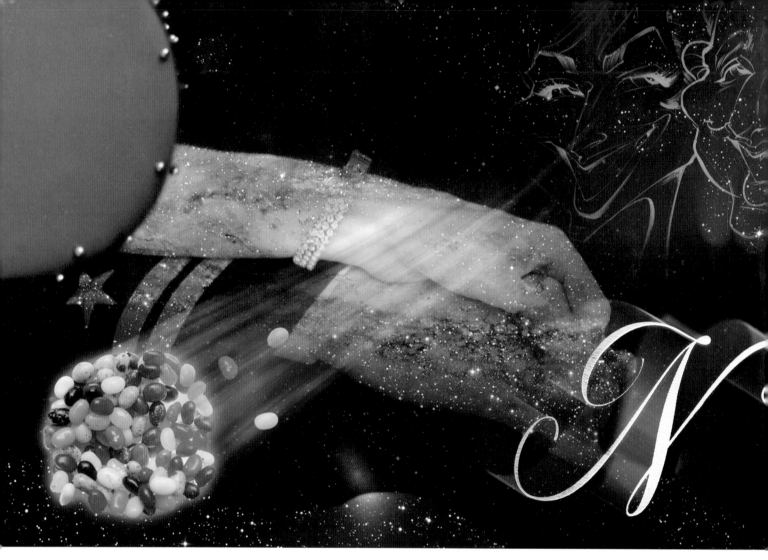

Brush is a Good Brush" (page 101) for vital information on using the soft-brush technique.

2-26. Cosmic Journey *with the Caricature Gemini element in place. This completes our project.*

The Results

Save your work. Do your results look like image **2-26**? Congratulations! You have completed a rather complex project using several advanced skills. The montage is made of five objects that mean a lot to the newlyweds. It is creative and aesthetically pleasing. When they look at this page twenty years later, it will surely bring them a nostalgic feeling.

The Making of a Bride

COMPLEXITY LEVEL
Low

TECHNIQUES INVOLVED
Soft-Brush Technique, Layer Masking

The process of the bride getting ready for the wedding provides many opportunities for great images. Since my style is mostly photojournalistic, I do my best not to interfere (well, once in a while I might step on the dress and hear screams echoing through the room) and be an observer. Read "What the Wise Man Says 10: The Importance of Being Real" (below) for some insights on wedding photojournalism.

In this project, we will create a collage using four images that show different perspectives on the bride getting ready—interactions between the bride and her mother, a closeup of the detailing on the bride's headdress, "something old" being pinned to the bouquet, and the bride's shoe being shown off (images **3-1** to **3-4**). If you'd like to follow along, you may download practice files from Amherst Media's web site (see page 8).

Let's get started.

> *In this project, we will create a collage using four images . . .*

WHAT THE WISE MAN SAYS 10

THE IMPORTANCE OF BEING REAL

When I design an album, my goal is to preserve memories. When the couple opens up their album at their thirtieth anniversary, I want them to be able to relive every special moment. The pages should bring back all the laughter and the tears of joy.

In order to achieve this goal, the activities portrayed in the album should be real. Some photographers like to "stage" events—say, the bride's mother helping her put on her necklace. While an album that consists of staged images might look fine to unsuspecting eyes, these images do not mean a thing to the couple. For them, this was what the photographer directed them to do.

Capturing real events is much harder than shooting staged events. You need to be watching and shooting all the time. If you let your guard down for a second, you might miss the bridesmaid wiping tears away, or the father of the bride giving the groom a man-to-man hug.

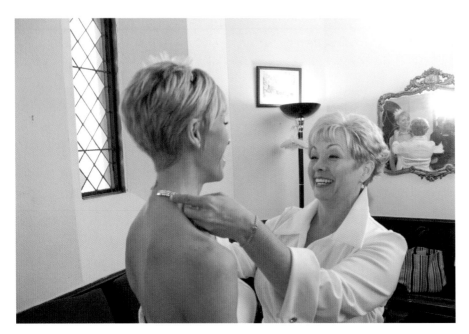

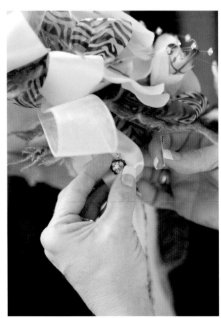

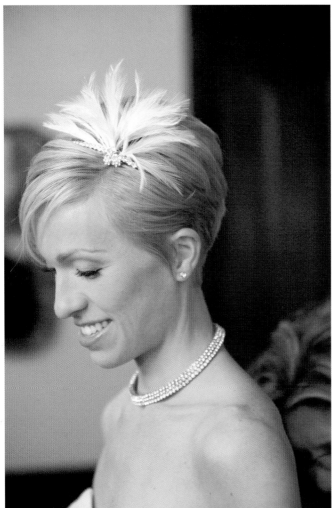

3-1 to 3-4. These four images provide different perspectives on a bride getting ready for the ceremony.

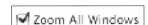

3-5. Check Zoom All Windows in the Options.

Prepare the Canvas

Open the practice files, then go to Window > Arrange > Tile Horizontally so you can see all the images. Press Z to go to the Zoom tool. Check Zoom All Windows in the Options (as seen in image 3-5), then move the cursor to the active window, press and hold Alt (Mac: Opt), and click to zoom out until all of the images can display completely in their windows.

Now, we need a canvas. Go to File > New to create a canvas for the montage. Make it 20 inches wide and 13.5 inches high at 100dpi. Type "Making a Bride" in the Name field, then click OK. This resolution setting is good only for practice purposes; you would need three times the resolution if you were actually going to print this file.

The Main Attraction

We will make the bride a star. Let's start with the image of our sophisticated-looking bride glancing down. Press V to activate Move tool, then drag this image into the Making a Bride canvas. In the Layers palette, rename this new layer "Head."

Hit Ctrl-T (Mac: Cmd-T) to Free Transform the Head layer. While holding the Shift key to retain the original aspect ratio, click and drag one of the corner handles outward to enlarge the layer until its height is just a little greater than the height of the whole canvas. Hit Enter to apply the Free Transform.

Use the Move tool to place the Head layer so it will fully cover the left side of the canvas from top to bottom without leaving any gaps.

We will use a background color that make the subjects "melt" into it. Why not use the skin color of the bride? Press I to activate the Eyedropper tool, then

3-6. Using the Eyedropper tool to sample the bride's skin color.

move your cursor to the area of skin immediately below the necklace. Click and sample the color there, as seen in image **3-6** (previous page).

Look at the foreground color at the bottom of the Tools, it should be a nice beige color that resembles the bride's skin color. In the Layers palette, click on the Background layer to activate it. Then hit Alt-Backspace (Mac: Option-Delete) to fill the current foreground color to the Background layer. Your collage should look like image **3-7**.

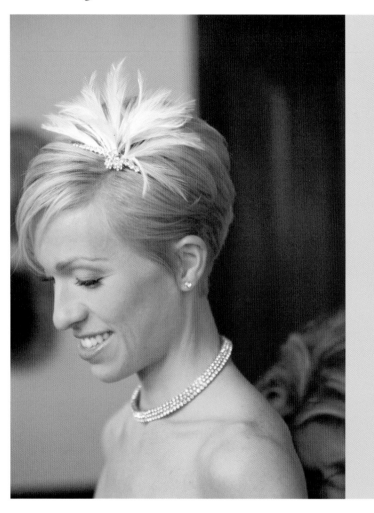

3-7. *The collage with the bride's closeup and the background color.*

We will now use the soft-brush technique to make the bride "melt" into the background. First, we will completely mask out the Head layer using a Layer Mask. In the Layers palette, click and activate the Head layer. Then, Alt-click (Mac: Option-click) on the Add Layer Mask icon at the bottom of the Layers palette to add a black Layer Mask to the Head layer. Now, the bride's image has disappeared. We will use Brush tool to bring her back little by little.

Press B to activate the Brush tool. In the Options, set the opacity to 20 percent. Use Shift-[to turn the hardness all the way down to 0 percent (watch the brush-size setting in the Options; the symbol above the brush-size number should look very fuzzy). Use [and] to adjust the size of the brush to be about

the size of the bride's forehead—about 400 pixels as displayed in the Options. Make sure the foreground color is set to white and that the Head layer's Layer Mask is active.

Place the brush on the canvas where the bride's face should be, click (*but do not hold!*) and watch the result. Getting the desired results here requires subtlety. Keep in mind that we are using a low-opacity paint to bring back a semi-transparent image. However, even low-opacity paint can build up to a higher opacity when you repetitively paint on the same spot. It's the same as real-world spray painting.

Move the brush around and click a couple more times until you can see a very faint image of the bride. This should look like image **3-8**.

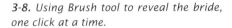

3-8. Using Brush tool to reveal the bride, one click at a time.

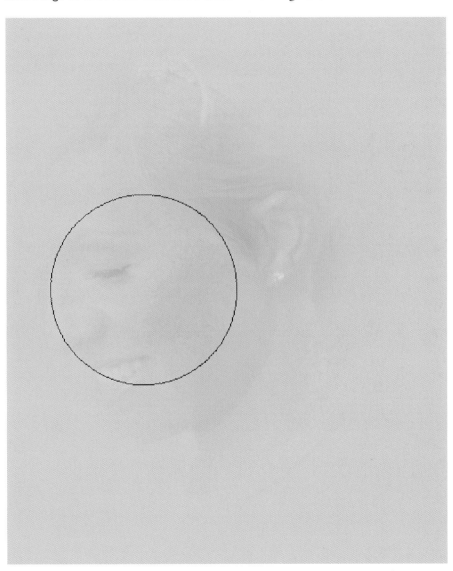

Drop the opacity setting of the Brush tool to 15 percent and reduce to brush diameter to 250 pixels. Again, use single clicks on various spots, now working on the area of the hair and headdress to reveal them.

Reduce the brush diameter to 80 pixels and keep the same opacity setting. Using a motion that radiates from the center of the headdress out toward the

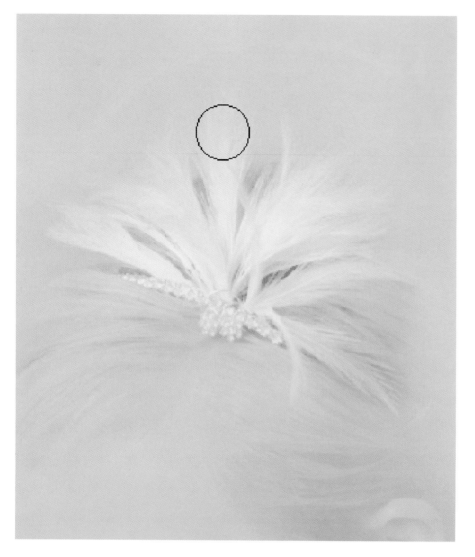

3-9. *A small brush is used to accentuate the feathers.*

ends of the feathers, click and hold to paint. Release the click when your cursor reaches the ends of the feathers, as seen in image **3-9**. We are accentuating the headdress, but, again, with great subtlety.

Repeat the same steps for the eyes, mouth, earring, and necklace. Adjust the brush diameter as necessary and always keep the opacity as low as 15 percent. If you think the opacity is too low, build up the effect slowly using multiple brush strokes. (In case of overpainting [revealing too much], hit X to swap the foreground color with the background color [black], increase the opacity setting if necessary, and paint the undesired area out. Hit X again to go back to the task of revealing the bride.) When you are done with these steps, the collage should look like image **3-10**.

In the Layers palette, Alt-click (Mac: Opt-click) on the Layer Mask for the Head layer to see the Layer Mask alone—as seen in image **3-11**. This gives you a good

If you think the opacity is too low, build up the effect slowly . . .

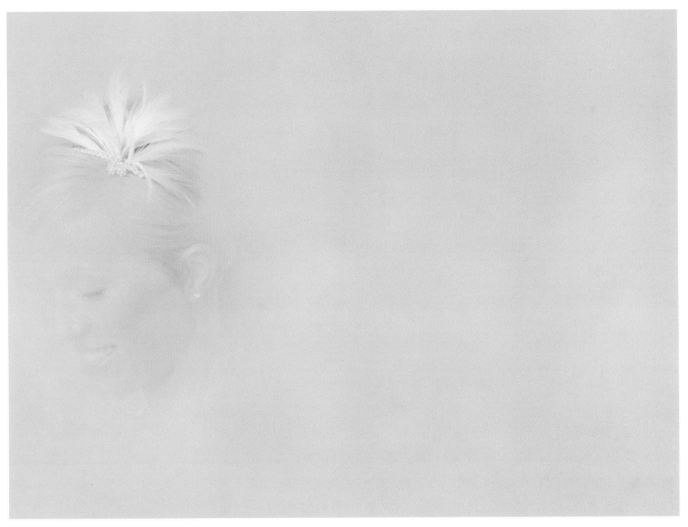

3-10 (above). With the help of a Layer Mask, the bride is emerging with great subtlety.
3-11 (left). The Layer Mask of the Head layer would look like this.

idea of how this technique works. The black areas are hiding the image completely. The lighter areas reveal them with low opacity. The soft dropout between the dark and light areas is made possible by using a very soft brush and carefully painting at a low opacity.

Interactions and Accessories

Now we are going to bring in the other three images. Basically, we will be employing the same soft-brush technique to achieve the same degree of subtlety. The Layer Masking processes will be a bit more straightforward than for the Head layer, though, which has a more complicated structure.

Using the Move tool, drag the image of the mom putting on the bride's necklace into the Making a Bride canvas. Rename this layer "Bride and Mom." Free Transform the Bride and Mom layer so that the distance between their faces is

about 2.5 inches. (Don't have a ruler? Hit Ctrl-R [Mac: Cmd-R] to turn it on.) Use the Move tool to place this image at the top right corner of the canvas.

Now we will again create the soft, subtle look. Alt-click (Mac: Option-click) on the Add Layer Mask icon at the bottom of the Layer Mask. A black Layer Mask is added and the image of the bride and her mom disappears.

Press B to activate the Brush tool. Use a brush diameter of 400 pixels, adjust the opacity to 75 percent, and set white as the foreground color to paint the image back in. Start from the faces—clicking, stopping to observe the effect, then clicking again. For areas that need accentuation, accumulate more clicks. Again, in case of overpainting (or if you accidentally reveal an image edge), swap the foreground color to black and paint these areas back out.

When you are done, the collage will look like image **3-12**.

Turning to the shoe image, use the Rectangular Marquee to select the area around the bride's foot. (Leave plenty of area around the subject in this shot. Read "What the Wise Man Says 16: Always Keep More Than You Need" [page 63] for a good practice.)

Using the Move tool, drag the selected area into the Making a Bride canvas. Rename this new layer "Shoe." Free Transform this layer so that the shoe is about three inches long and place it below the image of the bride and her mom.

3-12. This is the collage with the image of the bride and her mom added.

Swap the foreground color to black and paint these areas back out.

Using the Move tool, drag the "something old" image (pinning on the pendant) into the Making a Bride canvas. Rename the layer "Something Old." Free Transform this image until the pendant is about half an inch tall, then place the image to make it occupy the area between the Head layer and the other two images.

Repeat the soft-brush process on the "shoe" and "something old" layers. When you are done, your collage should look like image **3-13**.

The Results

This is an example of a collage that is totally free from hard edges. I like the organic look of it. We live in a modern world that is full of vertical and horizontal lines. It is refreshing to look at a collage that is free from them.

3-13. The finished project.

PROJECT 4
The Architectural Wonder

COMPLEXITY LEVEL
Medium

TECHNIQUES INVOLVED
Selection, Layer Masking, Layer Blending Modes, Adjusting Brightness with Levels, Color Correction with Levels

am a fan of architecture. If I had a chance to go back to my college days and pick another major, I might choose architecture. Since I am *not* going back to college, though, I'll settle for working architectural wonders into my albums.

In this particular case, the bride chose to get married in a beautiful, historic church. Obviously, she was fond of the architectural features of the church. Therefore, working them into a montage will make perfect sense. It will also

4-1 and 4-2. These are the source images for our montage.

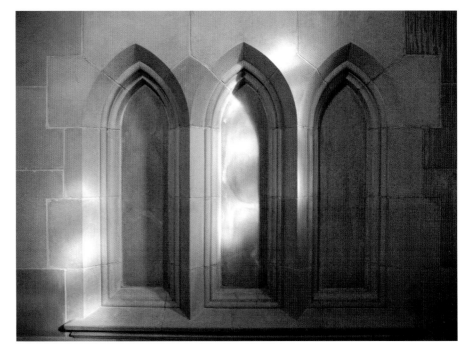

I happened to be passing by that corner when inspiration struck.

make the bride happy to see that the extra fees she paid for a nice church have become a lasting impression in her album. Read "What the Wise Man Says 11: The Psychology of Album Making" (facing page) for tips on picking the brain of a wedding client.

We will be using two images in this montage, images **4-01** and **4-02**. If you want to follow along, you will find these files on Amherst Media's web site (see page 8). One of the images is the bride getting ready, the other is a set of three window-like niches tucked away in a little corner of the church. I happened to be passing by that corner when inspiration struck. Ideas for this montage were already being shaped as I was shooting it.

Prepare the Canvas

Open the practice files, then go to Window > Arrange > Tile Horizontally so that you can see both of the images on your screen. Press Z to go to the Zoom tool, then check Zoom All Windows in the Options.

Move the cursor to the active window, then press and hold Alt (Mac: Opt) and click to zoom out until both of the images are completely visible in their respective windows.

Now we need to create a canvas. Go to File > New to create a canvas for the montage. Make it 20 inches wide and 13.5 inches high at 100dpi. Type "Bride in Windows" in the Name field, then click OK. (Again, this resolution setting is good only for practice; for actual output you would need three times greater resolution.)

Set Up the Stony Backdrop

Press V to activate the Move tool. Click on the image of the window-like niches and drag it into the Bride in Windows canvas. In the Layers palette, rename this new layer "Windows."

With the Windows layer selected, hit Ctrl-T (Mac: Cmd-t) to Free Transform. Hold Shift to maintain the original aspect ratio while you click and drag one of the corner handles to enlarge the image. Make the Windows layer large enough to cover the whole canvas without leaving any gaps.

I placed the Windows image off center, to the right, so that more of the beautiful highlights were featured. You can compare your work to image **4-3**. If your composition is not like mine, you may need to Free Transform or use the Move tool to tweak it.

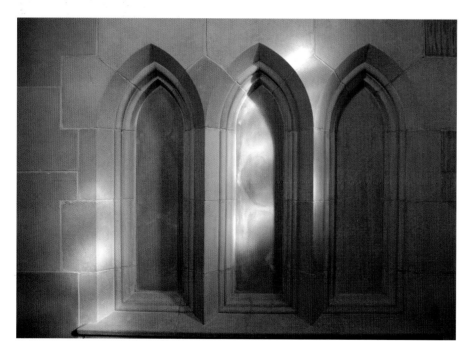

4-3. Positioning of the Windows layer.

Here Comes the Bride

Now, let's bring in the image of the bride. Use the Move tool to drag the bride's image into the Bride in Windows canvas. Rename this new layer "Bride." In the Layers palette, go to the top left corner and reduce the opacity of the Bride layer to 50 percent. This will allow us to better see the relative positions of the bride and the windows.

The next step is to Free Transform the Bride layer so that the height of the Bride layer will cover the height of the tallest part of the windows. Move the bride's image around so her facial features are nicely framed in the window to the far right.

At this point, your montage should look like image **4-4**.

4-4. The placement of the bride's image in the montage.

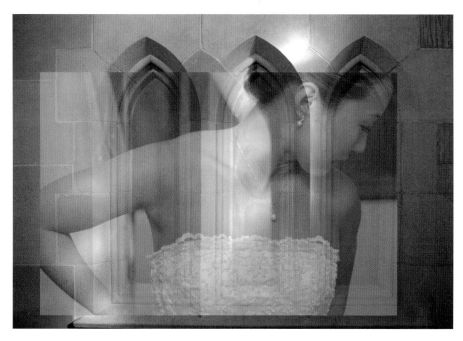

Frame the Bride

We will now create a Layer Mask on the Bride layer so that the image will be presented as a mural framed in the windows. In order to do that, we first need to make a selection in the shapes of the windows. To do this, click on the Lasso tool or press L to activate it, as seen in image **4-5**.

4-5. The Polygonal Lasso tool.

Now we will trace the shapes of the windows. Click on the eyeball icon on the left side of the Bride layer to turn the layer off. (*Note:* If your Bride layer is still at 50 percent opacity, turn it back to 100 percent opacity first to avoid confusion later.)

Starting with the window on the left, use the Polygonal Lasso to trace the inside of the window. Click at the lower left corner, then move the cursor straight up to the point where the curvature starts, click on that point. From here and up, click and place short segments of straight lines to fit into the curve. Before you get to the tip of this window shape, you should have made seven to ten clicks. Use

a similar technique to finish tracing the whole window shape. (Read "What the Wise Man Says 8: The Magnificent Magnetic Lasso" [page 30] for tips. Although we are using the Polygonal Lasso, most of the tips still apply.)

With Polygonal Lasso still active, go up to the Options and click on the Add to Selection button, seen in image **4-6**. Repeating the same steps used to select the left window, select the center and right windows. When you are done you should have the selection seen in image **4-7**.

4-6. The Add to Selection mode.

4-7. The selection of the windows.

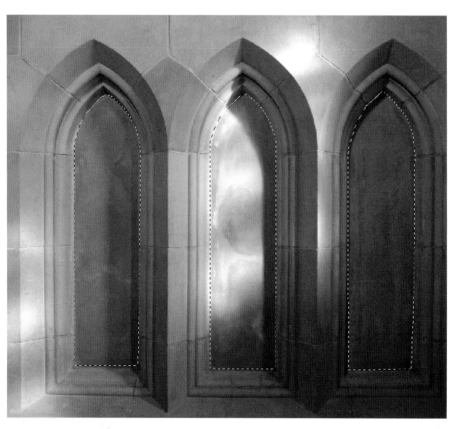

We will eventually turn this selection into a Layer Mask. (Read "What the Wise Man Says 6: Selections *vs.* Layer Masks" [page 25] to get a bit of background knowledge on that topic.) Before that, however, we have to adjust the edge of the selection. (For this, there is another one to read: "What the Wise Man Says 7: The Fuzzy Reality" [page 27].)

In the Layers palette, turn on the Bride layer by clicking on the eyeball icon. Now our window-shaped selections are right on top of the bride. We accomplish the next operation in two ways: the CS3 (and later) way and the pre-CS3 way.

The CS3 (and later) way is to go to Select > Refine Edge to bring up the dialog box. Make sure Preview is checked. At the bottom, expand the Description so it explains to you what each setting is about. Right above the Description, choose the icon for viewing over a black or a white background. Set everything to 0 except for the Feather setting. Play with this a bit by dragging the slider

Now our window-shaped selections are right on top of the bride.

across the whole range and seeing how the changes affect the look. Finally, adjust the Feather setting to 2 and click OK.

The pre-CS3 way is to go to Select > Feather. In the dialog box, set the value to 2 pixels and click OK. As you can see, the CS3 way and the pre-CS3 way produce exactly the same effect. The Refine Edge dialog box, is much more informative and interactive, though. You can also set the values in much finer increments. In the good old Feather dialog box, you can only enter integers.

In the Layers palette, make sure the Bride layer is active. Go to the bottom of the palette and click on the Add Layer Mask icon. A Layer Mask will be attached to the Bride layer, masking the Bride layer in the shapes of the windows.

Alt-click (Mac: Opt-click) on the Layer Mask and you will see the Layer Mask itself, as seen in image **4-8**. Your montage will now look like **4-9**.

4-8. The Layer Mask created from the selection.

4-9. The Layer Mask applied to the bride's image.

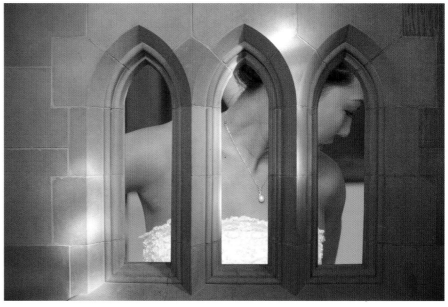

LAYER BLENDING MODES ARE FULL OF SURPRISES

Layer Blending Modes control how a layer interacts with the layer under it. In the Normal mode, they do not blend at all. Each of the other settings applies a different mathematical formula to create a series of unique effects.

Some of them are easily understandable. For example, Darker Color (new to CS3) compares the two images and displays whichever is darker at any given spot. Some are harder to predict based only on their names. Here is a good tip for getting to know them: *try them all.*

You see, Layer Blending Modes are full of surprises. We are talking about mathematically combining two complex sets of data. It is rather hard for anyone to foresee the precise effect. Trying them all makes sure that you are not missing anything—and it is fun to watch, anyway.

If you read "What the Wise Man Says 7: The Fuzzy Reality" (page 27) you will notice that the Contract procedure was not applied here when we did the Refine Edge. Why? Do you want to think about this before I give you the answer? I will announce the answer at the end of this chapter (see page 59).

Make it a Mural

So, the bride is nicely framed in the windows—but the effect certainly does not look convincing. The image of the bride is there, but it doesn't look like it's *there*. We need to blend it into the stone wall in a way that it will look like a mural. Layer Blending Modes come to mind. Read "What the Wise Man Says 12: Layer Blending Modes are Full of Surprises" (above) if you are not familiar with this topic.

In the Layers palette, make sure that the Bride layer is activated. At the top of the palette, click on the pull-down menu right under the Layers tab. By default, it says Normal. Try a few different Layer Blending Modes and observe the effects. Look at images **4-10**, **4-11**, and **4-12** for a few examples; some look better than others. My heart is set on the Darken mode, seen in image **4-13**. I chose Darken because it best conveyed the "stony" look.

The bride is nicely framed in the windows—but the effect certainly does not look convincing.

Tweak for Perfection

Looking at image **4-13**, there are two things that could be a little better. One is that the montage appears rather dark, especially on the right. The other is that the right side has much more green and yellow than the left side. Let's fix those issues.

We'll fix the brightness problem first, using Levels. Should we just use Image > Adjustment > Levels? The answer is a big *no!* We will use Levels on an Adjustment Layer instead, because this is a nondestructive technique.

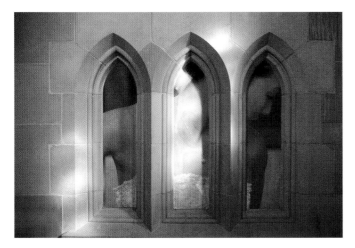

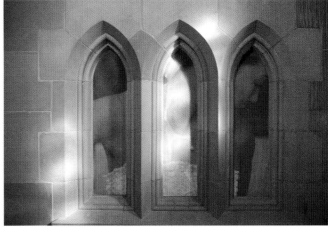

4-10, 4-11, and *4-12.* Examples of a few Layer Blending Modes.

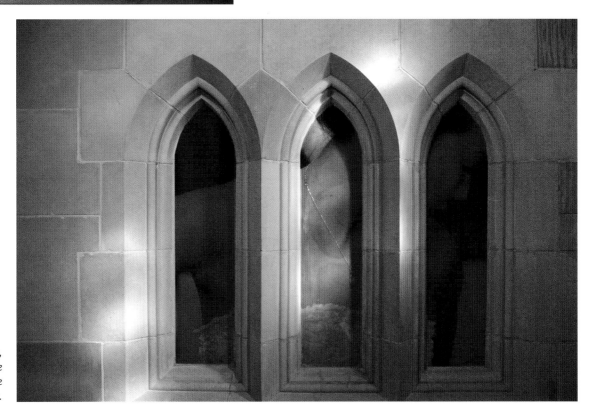

4-13. To me, the Darken mode best conveys the "stony" look.

4-14. *The unadjusted Levels for the Bride layer (CS3).*

4-15. *Here, the white and midtone Input Levels have been adjusted for the Bride layer.*

(Read "What the Wise Man Says 3: Regrettable Procedures *vs.* Nondestructive Procedures" [page 12] for more on this topic.)

___In the Layers palette, make sure that the Bride layer is active. Go to the bottom of the palette and click on the Create a New Fill or Adjustment Layer icon. Choose Levels and direct your attention to the Adjustments palette/Levels dialog box. (*Please note:* The interface for Adjustment Layers was changed in CS4. For more on this, please read "What the Wise Man Says 4" on page 17.) In the center of this palette/box is a histogram. You need to know what a histogram is to make Levels do the job for you. Read "What the Wise Man Says 13: Profiling the Brightness with Histograms" to learn about histograms.

Look at the histogram for the Bride layer (image **4-14**). There are a lot of pixels to the left of the midtone point (the triangular gray slider). They are on the dark side. They are all with Darth Vader! We need to send some of them to join the Jedis and bring balance to the Force—I mean, the brightness.

In the Levels dialog box (or Adjustments palette), click and drag the triangular white-point slider (under the histogram) to the left, stopping right where the right edge of the histogram starts. The value of the white point should read 230. Then, click and drag the gray midtone slider to the left until the value is 1.20. (*Note:* You can also type these values directly into the boxes below the corresponding sliders. The reason I asked you to drag the points instead of typing in the values is so that you could observe the changes.) When you're done, the Levels dialog box (CS3 or earlier) should look like image **4-15**; click OK to close the dialog box. In CS4 or later, the Adjustments palette will look like **4-16**; check it out, and then proceed to the next step.

4-16. *The Adjustments palette for the Bride layer (CS4).*

PROFILING THE BRIGHTNESS WITH HISTOGRAMS

The histogram is arguably the most important tool for tweaking an image. Let's have a look at the anatomy of it.

We will use an engagement shot, image **4-17**, as our example. Image **4-18** is the histogram for image **4-17**. Let's compare them. Histograms are unique to each image, so the histogram doesn't mean a thing if we don't compare it to its source image.

First of all, the vertical axis shows the quantity of pixels. Hence, a higher "mountain" means more pixels and a lower "valley" means fewer pixels. The horizontal axis shows the brightness: darker tones are to the left and brighter tones are to the right.

Points A, B, and C are the black, midtone, and white points respectively. They represent the darkest black, 50 percent gray, and the brightest white. Together, they mark three important thresholds on our brightness scale.

The red, mountainous landscape is the histogram itself. In this case, we have two groups of "peaks." The D group is rather to the left side, which means they are dark. Since these are the most massive mountains in the histogram, we know there are a lot of pixels in this category. Now look at the image. This area of the histogram represents the woman's dark outfit and the dark red background.

How about peak E? It is slightly brighter than the midtone and has quite a lot of members. I would say this represents the skin tones.

Area F here presents a hazard. You see, there seems to be a peak that's cut off by the black point. This shows that we have a large group of pixels that are so dark that they are all squeezed to the black point. Can you pinpoint the corresponding area? It is the shadowy part of the woman's outfit. When this happens, it is called clipping. Whenever there is clipping, there are lost details. In this case we lost the details in the shadow.

Finally let's look at the G area. Our histogram ends before it reaches the white point. This means there is no true white in this image. While the little peak (made of pixels from the white shirt) gets quite close to the white point, it is not quite there.

So generally speaking, this image is slightly underexposed.

The histogram provides us with an analysis of the brightness. The next thing to do is to use it as a gauge while we tweak the brightness. You can learn to do that in many examples in this book.

4-17. Our example image.

4-18. The histogram for our example image.

Look at the montage now. The right side is not as dark as it was, but the left side is now a bit washed out. To correct this, we will use the Layer Mask that came with the Levels 1 Adjustment Layer to localize the effect on the right side of the canvas.

In the Tools, click on the Gradient tool to activate it (or press G to do the same). If you do not see the Gradient tool in the tools, it is hidden under the Paint Bucket tool. Click and hold on the Paint Bucket to reveal the Gradient tool—or press Shift-G to cycle through these two tools. In the Options, make sure the default liner mode (the far-left selection of the five modes) is selected and the Reverse is unchecked.

In the Layers palette, make sure the Layer Mask on the Levels 1 Adjustment Layer is activated. If not, click on it.

At the bottom of the Tools, make sure the foreground and background colors are white and black, respectively. If not, press D to reset to the default foreground/background colors. If your rulers are not on, hit Ctrl-R (Mac: Cmd-R) to make them visible. Make sure the units in the rulers are inches. If not, right click on the ruler and change it.

Now, move your cursor to the montage. Place the cursor at a point 14 inches from the left and 8 inches from top. Click and hold, then drag the cursor up and to the left at about a 30 degree angle above the horizontal. Release the click 12 inches from the left edge and 7 inches from top.

You can see that we are pretty much painting a gradient across the transitional area between the shadow and the highlight. The Layer Mask would look like image **4-19**. It hides the effect of the Levels 1 layer on the left side, then gradually shows the effect through the gradient area. Finally, in the pure white area, the effect of the Levels 1 Adjustment Layer is visible at its full power.

We are pretty much painting a gradient across the transitional area . . .

4-19. *The Gradient pattern applied to the Layer Mask on the Levels 1 layer.*

Now the brightness is better balanced, but you might notice that the shadowy area still has a significant color shift toward green and yellow. This is the result of mixed lighting sources: the sun and incandescent bulbs. On the left side, the sun is predominant, so no problem is shown. On the right side, the

COLORS ANALYZED ON A WHEEL

While we humans do not stand out for our superior physical abilities among the members of the animal kingdom, our ability to distinguish different colors is ranked on the top. There are two types of humans: one is blessed with this ability to simply enjoy a colorful world; the other—called Homo Photoshopus (commonly known as Photoshop users)—is cursed to face an eternal struggle with color correction.

Alright, enough nonsense. My point is, color is a difficult topic for Photoshop users. Let's talk about color. Particularly, a color wheel like the one seen in image **4-20**.

A color wheel gives us a very good idea how the primary colors are related to each other. More importantly, it show us the *opposite* colors, the complementary colors, which are very useful in making color corrections. Remember, particularly, the complementary colors for red (cyan), green (magenta), and blue (yellow). When one color is increased, the complementary color is decreased. Use this principle when you make color corrections.

4-20. A color wheel.

sun is blocked, so the more yellow incandescent lighting is predominant—thus, the color shift. Let's fix it with another Levels Adjustment Layer.

One thing you'll notice here is that the color shift's locality coincides with the shadow area. This means that the Layer Mask we already created for the Levels 1 Adjustment Layer can be useful for our next Levels adjustment, which will be for color correction. Here is what we will do.

Ctrl-click (Mac: Cmd-click) on the Layer Mask of the Levels 1 Adjustment Layer. A selection is loaded. You can see the selection's border runs though the center of the Layer Mask's gradient area. This selection is the alter ego of the Layer Mask. (Read "What the Wise Man Says 6: Selections *vs.* Layer Masks" [page 25] to review the important correlation between the two.)

Making sure that Levels 1 is the current active layer, then click on the Create New Fill or Adjustment Layer icon at the bottom of the Layers palette and choose Levels. When you do so, a Levels 2 Adjustment Layer will be created in the Layers palette. Look at its Layer Mask. It is identical to the one on the Level 1 Adjustment Layer.

Now we will reduce the color shift. Look at the Levels dialog box, now related to the Levels 2 Adjustment Layer. You will see a Channels pull-down menu that says RGB at the moment. Click on that pull-down to see a list of the three channels. We will counter the color shift by adjusting these channels.

Click on the Channels pull-down and choose Green. At the Output Levels (this is the lower slider bar; do not accidentally adjust the Input Levels, which is the higher slider bar) click and drag the white-point slider toward the left until the value is about 223. I say "about," because color "correction" is not really about correctness; it is about taste. You need to look at the image and make your call.

You will see now the green color cast is reduced, but there seems to be a bit too much yellow. There is no Yellow channel here—but yellow is the complementary color of blue (opposite it on the color wheel). Therefore, increasing blue decreases yellow. As you can see, understanding the color wheel will come in handy when working in Photoshop. Please read "What the Wise Man Says 14: Colors Analyzed on a Wheel" (previous page) for more on this.

Click on the Channels pull-down again and choose Blue. In the Output Levels, drag the black-point slider to the right to a value of about 18. Doing this neutralizes the yellow. However, the shadowy area seems to be growing darker again. This is because we have reduced the Green channel more than we have increased the Blue channel. Therefore, a little compensation in the composite RGB channel is in order.

Click on the Channel pull-down again and choose RGB. Under the Input Levels, click and drag the midtone slider to the left to about 1.09. Click OK. The shadowy area has now regained its proper brightness.

The green color cast is reduced, but there seems to be a bit too much yellow.

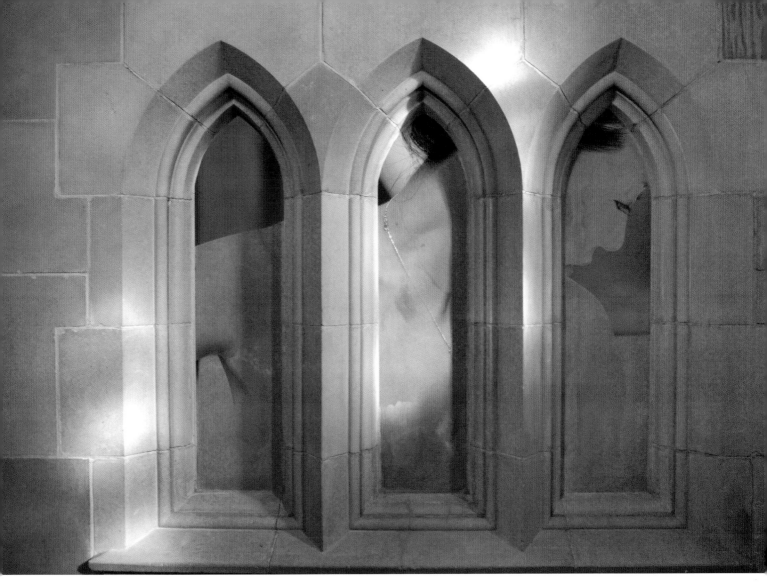

4-21. Our final work.

The Results

We are done! Does your montage look like mine, shown in image **4-21**?

A Final Note

Remember that question I asked you to consider back on page 52? Well, here's the answer. The reason we did not have to contract the selection is that we were not trying to isolate an object from its original background. Hence, we did not have the halo or fringing issue that is associated with overselecting the original background. In this case, we were simply shaping a mask through selection.

PROJECT 5
A Thumbelina Montage

COMPLEXITY LEVEL
High

TECHNIQUES INVOLVED
Preproduction Planning, Selection/Layer Masking Skills, Cloning, Color Adjustment Using Adjustment Layers

Many wedding photographers nowadays like to emphasize the "details" of the event. These details are usually still lifes of objects that are meaningful to the couple—for example, cakes, jewelry, autograph books, etc. It will be even more interesting if these details are presented *with* the couple.

The challenge is that these still lifes are normally a lot smaller than human figures. But how about turning our newlyweds into Thumbelina-sized fig-

5-1 and *5-2. Our original images for the montage.*

ures and placing them amidst the still lifes? That would be a interesting presentation with a twist: the details will now be larger than the people.

In this example, the couple will be having their first dance among the place cards. When creating a fantastic montage like this, the goal is to convince the viewer. If the viewer finds no conflicts with their common sense, if our Thumbelina look-alikes appear as though they really are tiny figures in fairy-tale surroundings, we have succeeded. If the viewer finds imperfections or traces of "Photoshopping," we have failed.

We will use two source images (images **5-1** and **5-2**) for this project. Again, the images are available for download from Amherst Media's web site (see page 8).

The Preproduction Planning and Execution

A few things were taken care of while capturing the source images for the montage.

While this is beyond the scope of Photoshop, the success of many image compositions requires planning before you sit down in front of your computer. (Read "What the Wise Man Says 15: Garbage In, Garbage Out" [next page] for some thoughts on the importance of preproduction.) In our Thumbelina montage, a few things were taken care of while capturing the source images for the montage.

The first step was the formation of the creative concept. This includes the basic idea for scaling down human figures to fit on the table-top display and a rough idea of the composition that would be used.

Next, I was on the watch for image compatibility. I had to make sure that the place-card shot was compatible with the people shot. The things I suggest watching for are:

1. **Consistency in Perspective.** The perspective of the images has to appear similar. This means that the angle of view on the tabletop display should match the angle of view on the dancing couple.
2. **Consistency in Lighting.** Non-directional, soft lighting was required on the couple to simulate the effect of the glowing candles on the table. As far as the color of the light, we can tweak that in postproduction.
3. **The Focal Plane and the Depth of Field.** In the tabletop shot, the focus needs to be placed at the spot where the Thumbelinas will be placed. A reasonable depth of field is needed so it looks right to keep the Thumbelinas sharp.

Look again at images **5-1** and **5-2**. You can see that they were shot with all these considerations in mind.

GARBAGE IN, GARBAGE OUT

In one of my past lives I was a computer programmer. The dot-com collapse helped in ending that life. All computer programmers are trained to apply the principle of "Garbage In, Garbage Out" while processing data. This means that if you start with flawed data, you can't possibly bring any sense back to it.

In my current (and less geeky) life as a Photoshop user, the "Garbage In, Garbage Out" principle still holds true. You can't create wonder if you have bad images to start with. This is the reason why a Photoshop user has to either work closely with the photographer—or be a photographer himself (or herself). You need images that are both technically and artistically optimized for your productions.

You can see examples of pre-production and post-production collaboration in this book. I will not, however, show you examples of processed garbage. That is not to say that I have never made the mistake—I've had plenty of my share of that. Have you? You don't need to be embarrassed. Admit it—but then repent and reform!

Prepare the Canvas

Open the practice files. Go to Window > Arrange > Tile Horizontally so you can see all the images. Press Z to go to the Zoom tool, check Zoom All Windows in the Options, then move the cursor to the active window. Press and hold Alt (Mac: Opt), then click to zoom out until all of the images are displayed completely in their windows.

Now we need a canvas. Go to File > New to create a canvas for our montage. Make it 20 inches wide and 13.5 inches high at 100dpi. Type "Thumbelina" in the Name field, then click OK. (Again, this resolution setting is good only for practice; for output you would need three times the resolution.)

The Candlelit Backdrop

We will use the table shot as the background. Press V to activate the Move tool. Click and drag the tabletop image into the Thumbelina canvas. In the Layers palette, double click on Layer 1 and rename it "Table."

Hit Ctrl-T (Mac: Cmd-T) to Free Transform the Table layer. Click on the middle of the image and drag it to the top left corner of the canvas, placing the top left corner of the image at the top left corner of the canvas. Holding Shift to maintain the aspect ratio, click and drag the handle at the lower right corner to expand the Table layer. Expand it until the whole canvas is covered by the image.

To create the look we want, we will need to make a precise selection of the couple . . .

Bring in the Thumbelinas

Now, let's bring in the couple into the canvas. To create the look we want, we will need to make a precise selection of the couple so we can cut out the

original background behind them. It is a definite no-no to select the couple in the original image and bring that cut-out into the collage canvas. It is much better to bring in the *entire* image, along with the entire original background, and then use a Layer Mask to remove the unwanted background areas. (Read "What the Wise Man Says 16: Always Keep More Than You Need" [below] for more on this.)

Activate the Move tool by pressing V. Then, click and drag the image of the couple into the canvas of the Thumbelina montage. Rename this new layer "Couple." You might think that the figures are too large and a Free Transform will be required to scale them down. Don't do it yet! When making selections, it is always better to have more pixels to work with. We should make the selection first, to remove the background, then transform the couple later to make them the correct size.

Select the Thumbelinas

Now, we will make selections of the bride and groom. These selections will later be converted into a Layer Mask to remove the original background. (For extra tips on using the Magnetic Lasso, read "What the Wise Man Says 8: The Magnificent Magnetic Lasso" [page 30]).

Zoom in to the lower left corner of the bride's dress, giving yourself a view approximately like that seen in image 5-3 (next page). Zooming in too much or too little will make the selection process awkward.

ALWAYS KEEP MORE THAN YOU NEED

WHAT THE WISE MAN SAYS 16

Most fancy collages/montages require getting rid of the original background and replacing with a different one. Intuitively, one would make the delicate selection, refine it, and bring the image into the collage/montage without the original background.

Doing this, however, eliminates the benefit you can reap from the nondestructive nature of Layer Masks. While using a Layer Mask, it is easy to use white and black paint alternatively to show and hide pixels. With this benefit, it is better to keep the original background so we can have greater flexibility in refining our selection.

Consider this scenario. You do the selection first, before you bring the image into the collage. However, you accidentally cut off the groom's finger—you took all of the body parts over to the collage and left the finger behind! In the collage, you notice the unfortunate involuntary amputation and you want to bring the finger back. The trouble is, you don't have it in the collage. You will have to go back to the original image and find the finger. If the same mistake was made while making the selection with the original background *in the collage*, you could simply paint white on the Layer Mask and bring the finger right back.

5-3. Zoom in to view the corner of the bride's dress.

Activate the Magnetic Lasso tool. Start the selection by clicking on the lower left corner of the dress. Move the cursor carefully upward along the edge of the dress. Anchor points, denoted by small boxes, will be placed automatically along the selection, as seen in image **5-4**.

If you made any mistakes, you can fix them without starting over from the beginning. Read the tips in "What the Wise Man Says 8: The Magnificent Magnetic Lasso" on page 30.

The Magnetic Lasso works fine in areas with sharp borders and high contrast on both sides of the border—and that is what we'll enjoy in this selection until we get to the area where there are some seat coverings behind her dress. The problem that will occur here is shown in image **5-5**. This is because the contrast of the nearby borders is greater than the border we actu-

5-4. The Magnetic Lasso places anchor points along the edge of the selection.

ally want to trace. The Magnetic Lasso, however robust, does not have the wisdom to know which border is the *wanted* border. Therefore, it simply sticks itself to the highest-contrast border.

5-5. *This is what happens with the Magnetic Lasso when there is no sharp border to follow.*

5-6. *Manually placing anchor points prevents the selection from jumping to the wrong border.*

If you need to undo any misplaced anchor points, back up your cursor to the area before the misplaced selection began. If anchor points were already placed in the wrong spots, hit Backspace (Mac: Delete) to cancel them one at a time. Then retrace the correct border—this time, forcing anchor points to appear in the proper places by clicking with the mouse. The forced anchor points should be placed often enough that the selection will not jump to the wrong border, as seen in image 5-6.

Whenever your cursor is about to run out of the window, press and hold the Space bar to change to the Pan tool. Then click and drag the image to reveal the areas to work on next. Don't attempt to pan with the scroll bars! You'll only make a mess. Also, avoid pulling the cursor out of the window to use the auto pan; it is quite likely to cause you trouble.

Avoid pulling the cursor out of the window to use the auto pan.

Continue tracing up the dress, panning when required. When you reach the bride's hair, overselect it—as seen in image 5-7. We will deal with the hair later when we have a Layer Mask.

5-7. *When you reach the hair, move the cursor further away and overselect the area.*

Continue on with the tracing. Skip (by overselecting) the groom's hair, as well. Force anchor points as needed and continue making the selection, now going downward.

When you reach the original point in the selection, watch for a tiny circle at the lower right of the cursor. This denotes closing the selection. Click to close the selection.

Now, we need to cut holes to remove areas of the background that are enclosed by body parts or clothing. There are three holes we need to cut. Two are on the either side of the bride's torso; the other is between the legs of the groom. We will do the latter first.

Activate the Magnetic Lasso. Go to the Options and click on the Subtract from Selection mode, as shown in image **5-8**.

5-8. *In the Options, click on the Subtract from Selection mode.*

Using the same method as in the previous steps, trace the space between the groom's legs. When the tracing approaches the origin and a tiny circle appears next to the cursor, click to close the selection.

As you can see, there are two levels of "marching ants" on the selection now. One appears on the edge of the couple, denoting where the selection begins. The second one, the one that we just made, denotes where the selection ends. So this is a "hole" in the selection.

Now, let's move on to cutting the other two holes. Have a look at the backgrounds in these two holes. They are rather chaotic—if you attempt to trace them with Magnetic Lasso, it will constantly be distracted to the wrong spots. It will drive you nuts! Poor results and mental-health degradation are guaranteed.

In a case like this, I prefer to use the Polygonal Lasso. We will approximate the curves using small segments of straight lines. **Activate the Polygonal Lasso. Then, make sure you are in the Subtract from Selection mode, as in the last step.**

Start tracing the hole to the left side of the bride. Place an anchor point by clicking whenever it is necessary to make a turn. When the curve is straighter, the distance between anchor points can be great. When turns get tighter, more anchor points are needed. Place them tightly together, as seen in image **5-9**. When the tracing arrives back at the origin, click to close the selection.

5-9. *When turns get tighter, more anchor points are needed.*

Repeat the procedure on the hole to the right side of the bride. We have finished the selection. The next thing to do is to refine it before we turn it into a Layer Mask.

Refine the Selections

Make sure you read "What the Wise Man Says 7: The Fuzzy Reality" (page 27) before you start on this procedure. It is always best to know *why* before you worry about *how*.

I will show you two different approaches for preparing the selection for Layer Masking. Which one you use will depend on the version of Photoshop you use.

For Photoshop CS3 and later, with the selections made in the previous steps still active, go to Select > Refine Edge. Adjust all the settings to 0 and choose to have a black background, as seen in image 5-10. Do not hit OK yet.

Check out the area of the groom's pants. You can see two problems here. First, there is a sliver of the original background on the edge of the pants,

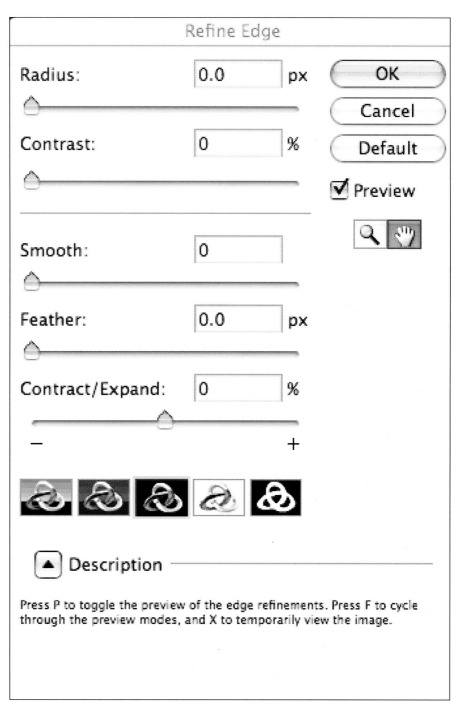

5-10. Adjust all the settings to 0 and choose to have a black background.

creating a halo. Second, the cut looks jagged, which makes the couple look like paper dolls, not people. See image **5-11**.

5-11. *Check out the area of the groom's pants. You can see two problems here.*

Now, change the Feather setting to 2.0 pixels and the Contract/Expand setting to –50 percent. Observe the same image area again and you will see that the halo has disappeared. ("What the Wise Man Says 7: The Fuzzy Reality" on page 27 offers an in-depth explanation of the mechanism behind this maneuver.) Click OK to accept the settings in the Refine Edge dialog box.

If you are using a version of Photoshop prior to CS3, you'll need to use a different approach. With the original selection of the bride and groom active, go to

Observe the same image area again and you will see that the halo has disappeared.

Select > Modify > Contract. When prompted, enter a value of 2 pixels. Click OK. Then, go to Select > Feather. When prompted, enter a value of 2 for the radius. Click OK. These steps achieve the same results as using the Refine Edge dialog box in Photoshop CS3 and later.

Moving forward, make sure the Couple layer is active in the Layers palette, then click on the Add Layer Mask icon at the bottom of the palette. The original background disappears (well, mostly—everything except the hair areas where we overselected in the previous steps). If you zoom in and pan around, you will find the edges of the Thumbelinas softly cut. Or would you? Did you see any boo-boos? I saw quite a few on my work. My boo-boo number one is that I accidentally cut off the groom's thumb. Ouch! Not to worry, though, digital amputations can easily be reversed with digital limb regenerations, thanks to the Layer Mask. Of course, you might have done a better job than I, or you might have made boo-boos elsewhere. The way to fix them all is pretty much the same, so for demonstration let's bring his thumb back.

Press B to activate the Brush tool. Use [and] to adjust the brush diameter so it will be a little smaller than the thumb, as seen in image **5-12**. Use Shift-[and Shift-] to adjust the hardness of the brush to about 75 percent.

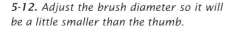
5-12. Adjust the brush diameter so it will be a little smaller than the thumb.

Look at the bottom of the Tools and make sure the foreground color is set to white. If not, press D to reset the foreground and background colors to black and white, and/or press X to swap the foreground and background colors.

In the Layers palette, make sure that the Layer Mask of the Couple layer is activated. Then, place the cursor where the groom's thumb should be and click and hold to paint. The thumb will reappear. Carefully paint the thumb back, but try to avoid overpainting. If overpainting occurs, revealing the original background,

press X to swap the foreground color to black and paint the unwanted background back out.

Get the picture? Go between black and white paint to refine the Layer Mask. Eventually you will make it perfect.

Mask the Hair

If you open up Photoshop books that cover hair-selection techniques, you will realize that those chapters are considered the holy scriptures of Photoshop. Authors come up with a fancy new technique and you can sense the pride they take in it and themselves. Good for them!

If you look closely, though, you'll notice that most of the example images in these books have backgrounds that are rather simple and solid. When this is the case, the hairs stand out against the background in stark contrast. We event photographers do not have that luxury. Just look at our image here. Behind the couple, there are all sorts of colors, brightness levels, and shapes. This would pretty much cripple those fancy techniques.

Therefore, I am going to continue to use the Brush and Layer Mask technique. It can be laborious and take a lot of trial and error, but it is very likely the only choice we have here.

Press B to activate the Brush tool. Use [and] to adjust the brush diameter to 15 pixels (about the size of the groom's left eye). Use Shift-[and Shift-] to adjust the hardness of the brush to 0 percent. At the bottom of the Tools, make sure the the foreground color is set to black. In the Options, set the opacity to 100 percent and the flow to 100 percent. Finally, in the Layers palette, make sure the Layer Mask on the Couple layer is active.

The first task is to get rid of the current hard edge as a result of our over-selection in the hair area. Let's do the groom's hair first. Place the cursor on the hard edge near the forehead. Click and hold to paint. Move toward the other side of the head, as seen in image 5-13.

Release the click and stop painting if you feel your hand is not steady. Reposition the cursor and start over. Repeat these steps until all the hard edges are masked out. Get as close as possible to the hair without actually touching it. At the end of this process, your image should look like **5-14**. The original background now looks like a halo around the hair.

Now we are going to mask out the edges of the hair. In order to create a gradual dropout at the edge, we will use a lower opacity setting. This also reduces the speed of change, so you can watch what you are doing without overdoing it.

In the Options, change opacity setting to 75 percent. With the circle of the brush falling slightly onto the hair, click and hold to paint, one area at a time. In some areas, where hair strands are sticking out, use sporadic clicks in between the

Now we are going to mask out the edges of the hair.

5-13. Click and hold to paint, moving toward the side of the groom's head.

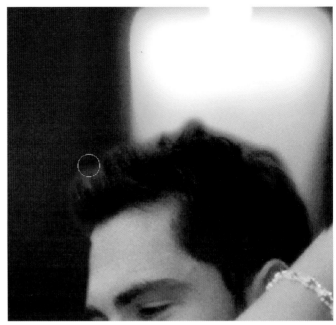

5-14. The original background now looks like a halo around the hair.

5-15. Keep masking until the halo from the original background is invisible.

5-16. After the masking process is complete, the groom's hair should look like this.

strands. Repeat these steps until the halo from the original background is invisible, as seen in image **5-15**.

Now for the final touch. This is done to create a semitransparent look between the strands of hairs or in the loops of some hairs—where hairs are not entirely blocking our view of the background area. In the Options, reduce the opacity setting to 20 percent. Among the hairs, find loops and ends of strands and click right on them. At the end of this step your image should look like **5-16**.

Now, do the same thing to the bride's hair. Her hair will be easier, because she hired a better hairdresser!

Shrink the Thumbelinas

Now, let's make the figures even smaller and move them to an open spot on the table where they can dance.

With the Couple layer active, hit Ctrl-T (Mac: Cmd-T) to Free Transform the layer. The layer now has a frame around it with eight control boxes. Hold Shift

5-17. The couple have been reduced in size and positioned on the tabletop.

to maintain the original aspect ratio, then click and drag any of the four corner boxes inward to reduce the image size. Drag the couple's image and put the them in place, as seen in image 5-17.

USING THE HISTOGRAM AS A GAUGE TO ADJUST AN IMAGE

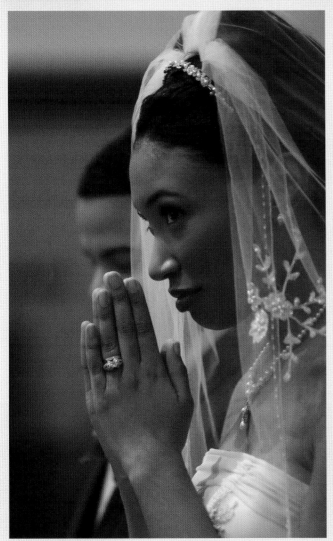

5-18 (top). The original image. 5-19 (bottom). The histogram for the underexposed image of the bride.

In "What the Wise Man Says 13" (page 55), you learned about how a histogram profiles the brightness of an image.

Now, let's learn how to use it in the Histogram dialog box as a gauge for our work. You can practice along with me if you have the downloaded file. Open the image "Under-exposed Bride" (seen in **5-18**) from the Box 13 folder. Turn on the Histogram palette by going Window > Histogram. Then go to the Layers palette, click on the Create Adjustment Layer icon and choose Levels. You are ready to go.

First, look at the Histogram dialog box. It will look like image **5-19**. In the Levels dialog box, an identical histogram is visible. As you can see from the right side of either histogram, there are no pixels on the brightest one-quarter of the horizontal scale. That confirms our suspicion of underexposure.

In the Levels dialog box, click and drag the white-point slider to the left—right to the foot of the "hill." Images **5-20**, **5-21**, and **5-22** (next page) show what happens in the image and on the histogram.

So the brightness is improved and the histogram confirms that, but the white gaps that result in the histogram are caused by a lack of data. There are certain brightness levels in the image now that are simply nonexistent. This is because we have "stretched" the histogram, leaving some gaps. It reminds me of the stretch marks on my back when I was growing two inches every year as a teen!

Also, the image is still too dark. The no-no here is to move the white-point slider over under the "hill" of the histogram. Doing that would create "clipping," which takes away image details. (See "What the Wise Man Says 13" on page 55). What you need to do here is to depend on the midtone slider.

Click and drag the gray midtone slider, moving it to left until it has a value of about 1.30. Images **5-23**, **5-24**, and **5-25** (next page) show what happens.

Now the brightness is all fixed. Looking at the Histogram dialog box you will see a more balanced shape between the bright and dark sides.

Mission accomplished? Yes. But before you go, I want to demonstrate another feature of the *(continued on next page)*

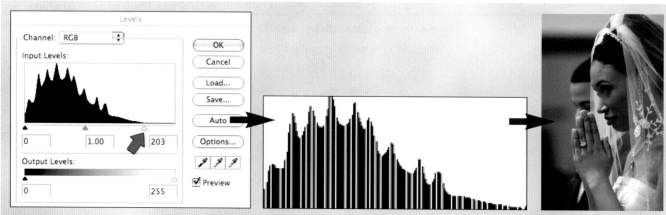

5-20 (left). *Moving the white slider.* **5-21 (center).** *The resulting histogram.* **5-22 (right).** *The change in the image.*

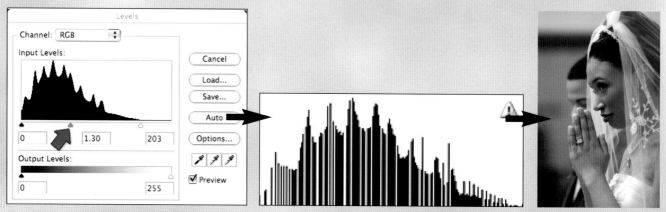

5-23 (left). *Moving the midtone slider.* **5-24 (center).** *The resulting histogram.* **5-25 (right).** *The change in the image.*

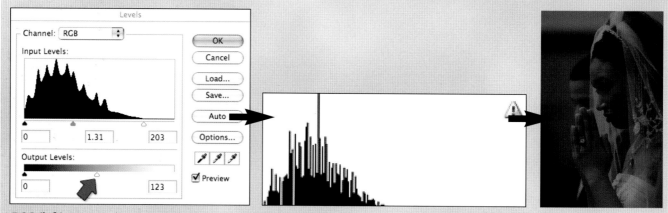

5-26 (left). *Moving the white-point slider in the Output Levels.* **5-27 (center).** *The resulting histogram.* **5-28 (right).** *The change in the appearance of the image.*

(continued from previous page) Levels dialog box: the Output Levels. While Input Levels are about expanding the contrast, the Output Levels are about limiting the contrast.

Click and drag the white-point slider on the Output Levels to the middle of the scale. Look what happens in images **5-26, 5-27,** and **5-28.**

The image now looks very dark because the Output Levels have constrained the whole range of brightness to the darker half. Look at the Histogram dialog box. The whole "mountain" is compressed to the left.

Put Them Under the Candle Glow

Looking back at image **5-17** (page 72), there are still a few things that throw off the illusion. First, the color of the light on the couple is too neutral. It has to be warmer to make them look like they are lit by the glow of the candles.

We will use Levels to adjust the color. If you are not familiar with Levels, read "What the Wise Man Says 13: Profiling the Brightness with Histograms" (page 55) and "What the Wise Man Says 17: Using the Histogram as a Gauge to Adjust an Image" (page 73). These are in-depth explanations of histograms and how to use Levels.

In this case, we will be manipulating the histograms for individual color channels so we can change the balance of power among them, hence changing the color. (Read "What the Wise Man Says 18: How We See Colors Through Black & White" below.)

WHAT THE WISE MAN SAYS 18

HOW WE SEE COLORS THROUGH BLACK AND WHITE

5-29. The color image. *5-30. The red channel.* *5-31. The green channel.* *5-32. The blue channel.*

Did you know that the sensors in digital cameras are actually color-blind? They actually only see black and white. How can we get color images from them, then?

When we press the shutter on a digital camera, three images were captured simultaneously. They are three black & white images, seen through red, green, and blue filters. Hence, each image represents the strength of one particular color. These tiny filters are fitted in front of each and every pixels, know as photosites. Talk about amazing technology!

For instance, look at images **5-29**, **5-30**, **5-31**, and **5-32**. The latter three images happen to be the Red, Green and Blue channels of the color image. Compare them. You can find a few fascinating phenomena.

First, the yellow umbrella looks very bright in the Red channel and very dark in the Blue channel. This means that the yellow color is largely created by mixing red. Barely any blue is used in making it. Second, the contrast between the blue sky and the cloud is at its highest in the Red channel. This is why the red filter was the choice when we photographed black & white landscapes on film—if you still remember what film is. Finally, the red outfit under the umbrella appears the brightest in the red channel.

Combine these three black & white images, give them the three primary colors, and we have a color image. Understanding how a color image is made is very helpful when learning color manipulations.

In the Layers palette, make sure the Couple layer is active, then go to the bottom of the Layers palette and click on the Create New Fill or Adjustment Layer icon and select Levels. In CS3 or earlier, without doing anything in the Levels dialog box, click OK. In CS4 or later, just leave the Adjustments palette alone.

Back in the Layers palette, move the cursor between the Couple layer and the Levels 1 layer. Press and hold Alt (Mac: Option) and you will see that the cursor turns into a double circle symbol. Right click between the two layers. Now you will see an arrow pointing down on the Levels 1 Adjustment Layer. This means that the Levels 1 Adjustment Layer is clipped to the Couple layer, as seen in image **5-33**. A clipped Adjustment Layer only affects the layer to which it is clipped. Therefore, we can now adjust the color on the Couple layer without affecting the Table layer, too.

In CS3 or earlier, double click on the symbol that resembles a histogram on the Levels 1 Adjustment Layer. This will bring back the Levels dialog box. If you use CS4 or later, simply activate the Levels 1 Adjustment Layer and turn your attention to the Adjustments palette. At the top of the dialog box/palette, click on the Channels pull-down menu and select Red. While observing the color shift on the Thumbelinas, drag the midtone slider to the left until its value is about 1.50—or to whatever value you think best makes the lighting on the couple blend in with the candlelit surroundings. As you can see in image **5-34**, we made the Red channel for the Couple layer brighter, therefore infusing more red color and making the lighting on the couple more compatible with their imaginary surroundings.

5-33. The Levels 1 Adjustment Layer is clipped to the Couple layer.

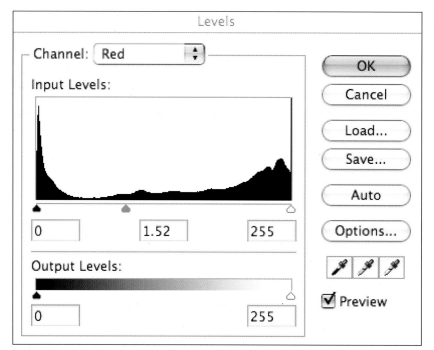
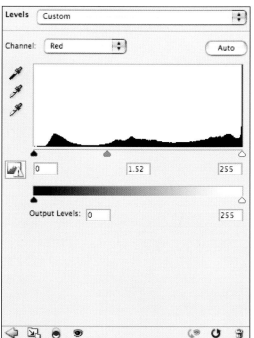

5-34. Adjusting the Red channel makes the couple blend in better with the candlelit surroundings. The left image shows the dialog box for CS3 and earlier. The right image shows the Adjustments palette for Photoshop CS4 and later.

What Is On Top Should Be On Top

When we make a montage, we are creating an illusion of something that does not exist. The illusion will be broken if it does not conform to common sense. Looking at image **5-35**, you can see that the bride's dress is in front of the place cards. This is not right! We have to fix it.

5-35. The bride's dress appearing in front of the place cards ruins the illusion.

5-36. Selecting the place cards with the Polygonal Lasso.

Take note of approximately where the cards are covered. Then, go to the Layers palette and turn off the Couple layer by clicking on the Layer Visibility (eyeball) icon. Activate the Table layer by clicking on it in the Layers palette. Then, use the Polygonal Lasso tool to make a selection of the corners of the cards that should cover the dress. Select more than is necessary—into the center of the cards—so they will not fall short, as seen in image **5-36**.

Next, go to Select > Refine Edge and apply the same settings we used when we were selecting the couple (see page 67). This will ensure that the edges of the cards conform to our "fuzzy philosophy" as detailed in "What the Wise Man Says 7: The Fuzzy Reality" on page 27.

Hit Ctrl-J (Mac: Opt-J) to jump the selected region of the Table layer to a new layer. Double click on the name of this new layer and rename it "Cards." In the Layers palette, click and drag the Cards layer upward and place it on top of the Couple layer. Click on the Layer Visibility (eyeball) icon in front of the Couple layer to turn it back on.

5-38. Observe the shadow of the bride in the original image.

Now, the cards will cover the bride's dress, which creates a scene that does not violate our common sense. This is seen in image **5-37**.

Let There Be Darkness

Our illusion is looking more and more convincing. But wait! Look at image **5-37** again. The bride seems to have a same problem that Peter Pan encountered: she does not have a shadow.

Let's play Wendy and make a shadow for her. The first question to ask is: what should the shadow look like? Why don't we have a look at how the shadow looked in the original picture? Image **5-38** gives you a zoomed-in look at the image. There, you will find a thin sliver of shadow under the rim

WHAT IS A SHADOW?

Put yourself under the sun or turn a light on. Raise your hand and cast a shadow from it. Observe the shadow. The object in the shadow is the same, but the brightness is reduced.

Now, think about this in terms of histograms and Levels. The change in the histogram, before and after the shadow is cast, is exactly a shift towards the left, as illustrated in image **5-39**.

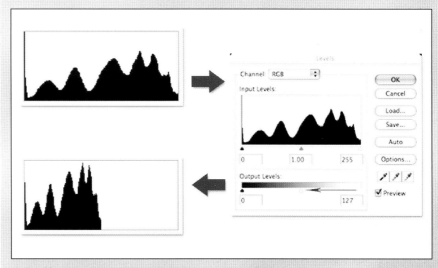

5-39. *If we drag the white-point slider of the Output Levels to the left, the whole histogram will be compressed to the dark side.*

As you can see in this illustration of the Levels dialog box, if we drag the white-point slider of the Output Levels to the left, the whole histogram will be compressed to the dark side; the pixels are now joining Darth Vader.

of the skirt. This is clearly the result of a very soft lighting. It won't be wrong if you produce a shadow that looks just like this.

What is a shadow? It is actually an image area with decreased brightness. Read "What the Wise Man Says 19: What Is a Shadow?" (above) to gain some insight on the shadow—from the perspective of the Balance of the Force. (Pardon me for my *Star Wars* fixation.)

Armed with this knowledge about shadows, we will now create a shadow using Levels. First we will sketch the shape of the shadow using the Polygonal Lasso tool.

In the Layers palette, make the Table layer active by clicking on it. Activate the Polygonal Lasso tool. Create a selection that resembles the shape of the shadow we observed in image **5-38**. When the selection is getting away from the rim of the skirt, simply cut through the whole width of the skirt and close the selection. The selection should look like image **5-40** (next page).

> What is a shadow?
> It is actually an image area with
> decreased brightness.

5-40. *The shadow selection should look like this.*

5-41. *As you adjust the Levels, a shadow will emerge.*

There are a few areas where we don't care to sketch the shape of the shadow carefully: behind the skirt and behind the cards. Our shadow will be behind them, so those parts of the selection will not show. We should not, however, forget that the edge of the shadow should look fuzzy, too. **Go to Select > Refine Edge. Leaving all the other settings at 0, adjust the Feather setting to 3 pixels. If you use a version of Photoshop prior to CS3, simply go to Select > Modify > Feather, enter 3 pixels, then click OK.**

At the bottom of the Layers palette, click on the Create New Fill or Adjustment Layer icon and select Levels. In the Levels dialog box, drag the white-point slider of the Output Levels to the left—approximately to the middle. A shadow will emerge, as seen in image **5-41**. It is important that the Levels Adjustment Layer for the shadow is *under* the Couple layer. Common sense prevails: Shadows are always under us, aren't they?

The Results

We have created the Thumbelina montage. Does your work look like mine, seen in image **5-42**?

5-42 *(facing page).* The final montage.

PROJECT 6
An Imaginary Space

COMPLEXITY LEVEL
High

TECHNIQUES INVOLVED
Three-Dimensional Visualization, Layer Blending Modes, Layer Masking, Adjustment Layers

Real life surroundings are often not so grand. Wedding settings are limited by the architectural possibilities at the venue, untidiness, and the amount of money people can spend on decor. I can't remember how many times I have had to shoot a bride getting ready in the nursery/storage room of the church. The backgrounds were eyesores that you certainly wouldn't want to feature in the albums.

6-1 to 6-4. The original images for this montage.

I wish the bride were somewhere else—and, in fact, that's one of the many illusions used to dazzle us in motion pictures: placing actors in nonexistent surroundings. Why can't we do the same? We might not have Steven Spielberg's team (or budget) at our disposal, but we have Photoshop and my secret recipe. Let's see how we can do it.

The Images

Have a look at images **6-1** to **6-4**. These are a series of candid shots of the bride getting ready with help from her parents—right up to the moment they leave for the wedding. Together, the images form a very vivid presentation of the exciting time.

Look at the image of the bride and her mom on the stairs. The staircase provides a very interesting frame for the subjects, who are looking up in the direction of the expanding space of the staircase. It's too bad the staircase is rather small and the continuation of space is rather limited. If we could enlarge the staircase, then maybe we could project the other three images onto the walls surrounding the staircase—almost as though they were murals on the walls.

Thinking in three dimensions is important here. Try to visualize how the three walls would look if they extended up much further. If you want to follow along, you can download practice files from Amherst Media's web site (see page 8).

Bring in the Stairs

Open the practice files. Then, go to Window > Arrange > Tile Horizontally so you can see all of the images. Press Z to go to the Zoom tool, check Zoom All Windows in the Options, then move the cursor to the active window. Press and hold Alt (Mac: Opt) and click to zoom out until all of the images can display completely in their windows.

Prepare the Canvas

Now we need a canvas. Go to File > New to create a canvas for our montage. Make it 20 inches wide and 13.5 inches high at 100dpi. Type "Staircase" in the Name field. Click OK. (Again, this resolution setting is good only for practice purposes; for print output you would need three times the resolution.)

Activate the Move tool by pressing V. Click on the image with the stairs to activate it. Click and hold the image, then drag it into the Staircase canvas. In the Layers palette, double click on Layer 1 and rename it "Stairs." Use the Move tool to place the Stairs layer so that its left edge falls on the left edge of the canvas. Hit Ctrl-T (Mac: Cmd-T) to Free Transform the Stairs layer so that it fills about half of the width of the canvas, as seen in image **6-5** (next page).

The staircase provides a very interesting frame for the subjects . . .

Extend the Staircase

Now we need to create the walls that were not there. Observe the existing walls. They are basically of the same color. So what creates the visible difference between the three walls? It's their brightness. A plan has formed: we will use a base color that resembles the existing wall color, then we will selectively adjust the brightness to match the brightness of the existing walls.

Press I to activate the Eyedropper tool. Click on the wall on the right side of the Stairs layer, where the color and brightness is about average. Notice, at the bottom of the Tools, the foreground color is set accordingly.

In the Layers palette, click on the Background layer to activate it. Currently it is white. Hit Alt-Backspace (Mac: Option-Delete) to fill the current layer with foreground color. Now the montage should look like image **6-6**. The background is set to match the color of the walls. You will find the color is best matched in the area where we sampled it with the Eyedropper tool.

Now, we will create the variations in brightness needed to define the walls. The plan is to use a couple of Levels Adjustment Layers to tweak the brightness—and to use the Layer

6-5. The Staircase canvas with the scaled Stairs layer in position.

6-6. The foreground color is used to fill the Background layer.

Masks on them to limit the adjustment to the areas of the individual walls.

Observe the two corners between the existing walls. One is on the top right corner of the Stairs layer, the other is at the lower right corner. We will extend them in the same direction. First, let's deal with the wall that goes at the top of the image.

Activate the Polygonal Lasso tool. Click on the lowest point where the top right corner starts. Pull the cursor up in the direction of the corner until the

cursor meets the edge of the canvas and click. Now, pull the cursor along the top edge of the canvas toward the left and click on the top left corner of the canvas. Go downward along the edge and click on a spot that falls into the Stairs layer. Go to the right and meet the origin. Click to close the selection. Your selection should look like image **6-7**.

This selection defines the area of the top wall. We will now alter the brightness of it. With the selection active, we will create an Adjustment Layer. This will come with a Layer Mask based on our selection.

In the Layers palette, click on the Background layer to activate it. Doing this makes sure that our Levels 1 Adjustment Layer, the one in charge of the top wall, will be *below* the Stairs layer. The Levels 1 Adjustment Layer will only affect the Background layer, not the Stairs layer.

At the bottom of the Layers palette, click on the Create New Fill or Adjustment Layer icon and choose Levels. In the Levels dialog box (CS3 and earlier) or Adjustments palette (CS4 and later), type 0.8 into the midtones field. In CS3 and earler, click OK. In CS4 and later, just move on to the next step.

This value shift in the midtone point sends more pixels to the "dark side." (Read "What the Wise Man Says 17: Using the Histogram as a Gauge to Adjust an Image in Levels" [page 73] if you are not entirely familiar with the mechanism behind this step.) The top wall is shaping up, as you can see in image **6-8**. However, there is an edge between the Stairs layer and the newly erected wall. We will need to hide that.

In the Layers palette, click on the Stairs layer to activate it. At the bottom of the Layers palette, click on The Add Layer Mask icon. Now, the Stairs

6-7. The selection of the top wall.

6-8. The wall is shaping up, but the visible edge between the existing wall and the new wall will have to be dealt with.

6-9. *Using a Layer Mask, the real wall and the "fake" wall are visually fused.*

6-10. *Creating a selection in the shape of the lower wall.*

layer has a white Layer Mask. Press B to activate the Brush tool. Use [and] to adjust the brush diameter to 80 pixels, as indicated in the Options. Use Shift-[and Shift-] to adjust the hardness of the brush to 0 percent. In the Options, make sure the opacity is set to 100 percent. Finally, at the bottom of the Tools, make sure the foreground color is set to black.

Now, starting from the top right corner of the top wall, place the center of the brush on the edge of the Stairs layer. Click and hold the brush, then move the cursor to the left to paint along the top edge of the wall. The edge of the Stairs layer will now be hidden, so the real wall and the "fake" wall are visually fused, as shown in image **6-9**. If the Layer Masking work is not quite satisfactory, continue

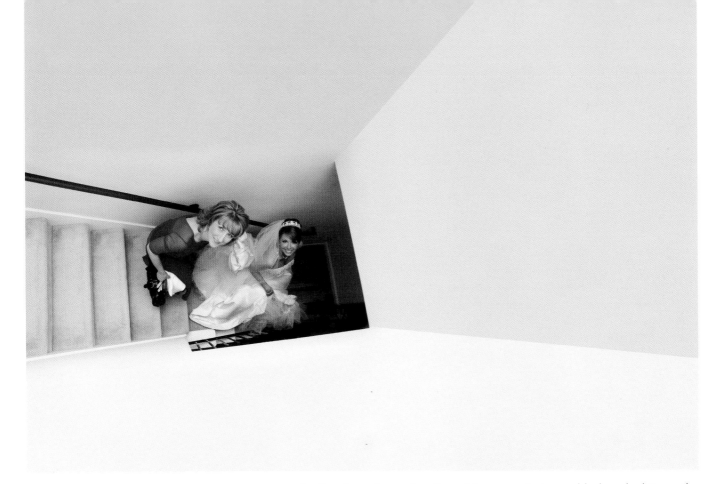

6-11. *This is what the image should look like so far.*

Use the Brush tool
to paint on the Layer Mask
of the Stairs layer . . .

to use the Brush tool to paint. Press X to swap between black and white as the foreground color in order to perfect the job.

Now, we will repeat the same procedure for the bottom wall. As you can see, the bottom wall is the brightest. Begin by creating a selection in the shape of the wall. When you're done, the selection should look like image **6-10**.

With the Background layer active, create another Levels Adjustment Layer to change the brightness of the bottom wall. Again this Adjustment Layer should be *under* the Stairs layer. This time, in the Levels dialog box, enter 1.8 in the midtone field to make the bottom wall brighter.

We now need to hide the edge of the Stairs layer. Use the Brush tool to paint on the Layer Mask of the Stairs layer—using same technique that we used for the top wall. While you're at it, use a Layer Mask to mask out the right edge of the Stairs layer. With the edges hidden, the montage should look like **6-11**.

Project the Murals to the Walls

We have created our imaginary space—but now we need to add the "murals" to the wall. Press V to activate the Move tool. Drag image **6-3** (the one with the mother clasping her hands in excitement) into the montage. Rename this layer "Top Wall Mural."

Hit Ctrl-T (Mac: Cmd-T) to Free Transform this layer. I will show you screen shots for each step—but *do not hit Enter or click OK* before you finish *all* the steps.

6-12. *The scaled layer is in position on the wall.*

6-13. *The layer is rotated to the right.*

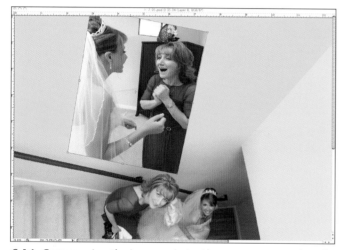

6-14. *Compressing the image mimics the correct proportions for viewing a wall mural from this high angle.*

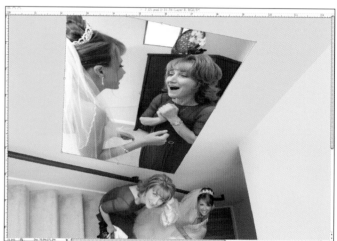

6-15. *The layer after correction for perspective.*

First, press and hold Shift. Then, scale down the layer and drag it into position on the top wall. When done, it should look like image **6-12**.

Now, move your cursor to somewhere near the bottom right control box but outside the layer itself. You will see the cursor turn into a curved arrow icon, which means you are ready to rotate the layer. Click and drag to rotate so the image is tilted to the right, as seen in image **6-13**.

Next, click and drag the middle box at the bottom edge upward. This is to compress the image in the direction of the imaginary extension of the wall. A tall mural on this wall would appear shorter when viewed from this high angle. When you are done, it should look like image **6-14**.

Right click on the transforming layer and select Perspective. Now, we are ready to change the perspective so the image appears to recede away from the viewer, following the wall. First, click and drag the top right corner box outward so the top edge becomes larger—making it look closer to the viewer. Then, click and drag the middle box on the top edge slightly to the right. This creates

the impression that we are looking at the layer from the right. When you are done, the layer should look like image **6-15**.

Soft Dropouts

Now that the perspective is correct, we are ready to create the impression of a mural by masking out the edges (using a Layer Mask) and by using the Layer Blending Modes to create the texture.

I absolutely love the soft-brush technique I am about to demonstrate here. It is the key to achieving an organic look in your collages. By using a brush with the lowest hardness setting and controlling the opacity of the paint on the Layer Mask, we can produce very soft dropout around an image. Read "What the Wise Man Says 20: A Soft Brush is a Good Brush" on page 101 for an in-depth explanation of how the soft-brush technique works. Also, check out "What the Wise Man Says 9: Brushes are Your Friends" (page 35) for essential tips on Brush tool usage.

In the Layers palette, make sure the Top Wall Mural layer is active. Look at the image of the mural and make a mental picture of where the faces are. At the bottom of Layers palette, press and hold Alt (Mac: Option) while clicking on the Add Layer Mask icon. This will give you a black Layer Mask, which makes the mural image disappear.

Press B to activate the Brush tool. At the bottom of the Tools, make sure the foreground color is set to white. In the Options, make sure the opacity is around **70** percent. This means that when you click briefly to paint, you only apply 70 percent of the color of the foreground—here, this will yield a light gray. With a light gray on the Layer Mask, the image will show through only partially. If you click a few more times on the same spot, the whiteness will accumulate and eventually become pure white. (If you are a math geek, you might argue that it will never get to be pure white. But this is reality, not math.)

Using the [and] keys adjust the brush diameter to around **250** pixels. Press Shift-[to make sure the hardness is all the way down to **0** percent. Place the cursor where the faces should be and give it a click. Do the same to both faces. Now you will see the faces emerge with great subtlety, as seen in image **6-16**.

6-16. When you click on the Layer Mask, the faces begin to emerge.

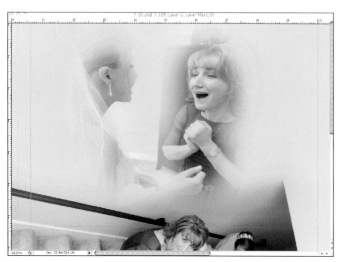

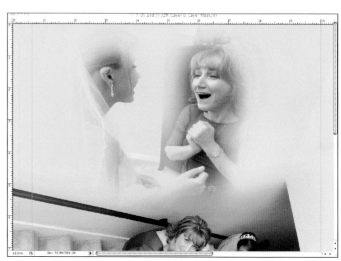

6-17. The edge of the image was accidentally revealed, but it can easily be concealed again by painting with black on the Layer Mask.

6-18. Changing the Layer Blending Mode of the Top Wall Mural layer to Luminosity.

Now, click around the faces, working your way out and avoiding the edges. Stop when all the details you want to see are there. It's quite likely you will make a boo-boo—like I did when I overpainted and revealed the edge of the image. In image **6-17**, you can see the lower left edge of the Top Wall Mural layer is exposed. If you make similar mistakes, hit X to swap the foreground color to black. Go to the Options and change the opacity setting to 100 percent. Reduce the brush diameter to around 175 pixels and paint the edge out (re-mask it). Leave the brush as far out from the edge as possible. Stop just when the edge disappears.

Now we will make sure that the faces have the full range of contrast. Keep the brush diameter set to 175 pixels and press X to swap the foreground color from black to white. Set the opacity back to 70 percent. Place the cursor on a face and click twice with a slight offset between the two clicks. Repeat the same process on the other face. Because we used a soft brush, a 70 percent opacity, and careful brush strokes, the dropout is as soft as possible.

Add Texture

Now, we will use the Layer Blending Modes to further the mural-like impression.

Make sure the Top Wall Mural layer is active. Then, at the top of the Layers palette, click on the pull-down that currently says Normal and choose Luminosity. When you do this, the montage will look like image **6-18**. The Luminosity Blending Mode keeps only the luminosity of the layer—the brightness of the image. Hence, it produces a monochromatic image. Read "What the Wise Man Says 12: Layer Blending Modes are Full of Surprises" on page 52 if you would like to know more about Layer Blending Modes.

The Luminosity Blending Mode keeps only the luminosity of the layer.

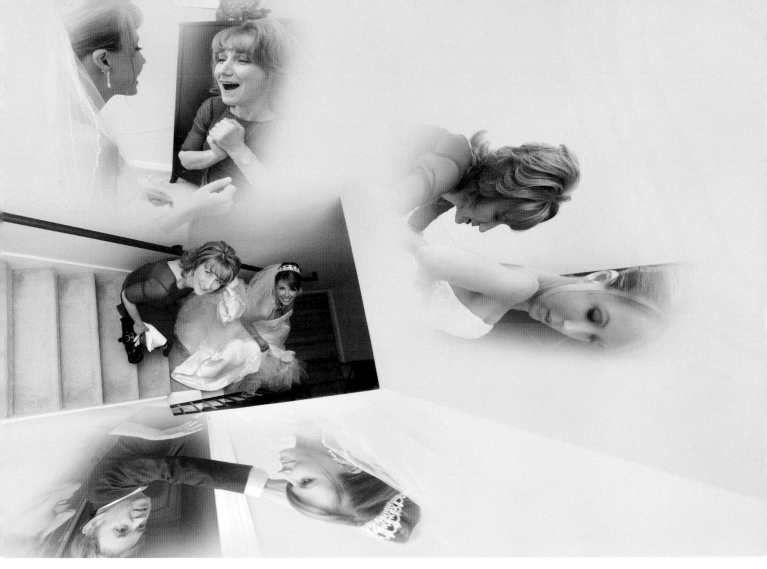

6-19. The final montage.

Create the Additional Murals

Repeat same procedures to create the other murals, placing image **6-1** (the mother zipping the bride's dress) on the right wall and image **6-2** (the bride with her mother and father) on the bottom wall. Note that image **6-2** will need to be turned upside down at the first step of the Free Transform.

The Results

As you can see, these steps require three-dimensional visualization. If you are new to this, you might find it a bit challenging. As a matter of fact, some background in technical drawing might help. (In one of my previous lives, I studied technical drawing; I loved it, but not enough to keep me doing it.)

If you do everything right, you will end up with a montage that looks like image **6-19**. How is your work?

Faces on a Cake

COMPLEXITY LEVEL
Medium

TECHNIQUES INVOLVED
Three-Dimensional Visualization, Layer Blending Modes, Layer Masking, Softening with Smart Filters

Here is another example of working in harmony with the efforts of the bride. In image **7-1**, you see a beautiful cake the bride carefully picked after months of bakery prowling. Images **7-2** to **7-5** are candid shots of precious moments during the reception. These images preserve memories, so why don't we work them onto the cake? We will create a montage called *Faces on a Cake*. (Read "What the Wise Man Says 5: You and Your Client as a Creative Team" on page 20 to gain insight on the philosophy of combining your

7-1. *The beautiful cake that was carefully picked by the bride.*

7-2 to 7-5. *Candid images from the reception.*

design strategies with your clients' creative efforts.) I should note that when I display a montage like this at a bridal show, I often get asked where they can buy a cake like this one. The answer is, get a plain cake and hire me (or *you*, since you're about to learn this trick, too) as the photographer!

Bring the Cake out of the Oven

Open the practice files (see page 8) and go to Window > Arrange > Tile Horizontally so that you can see all of the images. Press Z to go to the Zoom tool, check Zoom All Windows in the Options, then move the cursor to the active window. Press and hold Alt (Mac: Opt) and click to zoom out until all of the images are displayed completely in their windows.

Create the Canvas

Now we need a canvas. Go to File > New to create a canvas for the montage. Make it 20 inches wide and 13.5 inches high at 100dpi. Type "Faces on Cake" in the Name field, then click OK. (This resolution setting is good only for practice purposes; you would need three times the resolution for print output.)

Press M to activate the Rectangular Marquee tool. If the Elliptical Marquee tool shows up, press and hold Shift while pressing M to cycle between the two.

Click on the cake image if it is not activated yet. Then, click and drag a rectangular selection on the image. This should cover the width of the cake itself and extend from the bottom edge of the top layer down to the bottom of the image. We make this selection because we will not be using the whole cake. Bringing in just this area will reduce the file size. However, we do not want to select *too close* to what we want, either; it's always best to select a little extra so we have some wiggle room in case we change our minds. (Read "What the Wise Man Says 16: Always Keep More Than You Need" on page 63 for a good practice.)

Press V to activate the Move tool. Then, click on the selected area of the cake image and drag it into the Faces on Cake canvas. Rename this layer "Cake."

Hit Ctrl-T (Mac: Cmd-T) to Free Transform. To avoid distortion, press and hold the Shift key while dragging the corner box to enlarge the image. Drag the Cake layer around so that the lower two cake layers fill the canvas. (Wait a minute! The layers in the bakery world and the virtual-reality world are getting mixed up. Well the "Cake layer" refers to the Photoshop layer that has the cake on it; the "cake layer" refers to the baked goods. Am I making sense or am I making it worse?) In any case, the montage should now look like image **7-6**.

7-6. The montage with the Cake layer scaled and in position.

The Many Faces of a Cake

Now, let's bring an image of faces into the canvas. We will put the father-and-daughter dance image on the left side of the top layer of the cake.

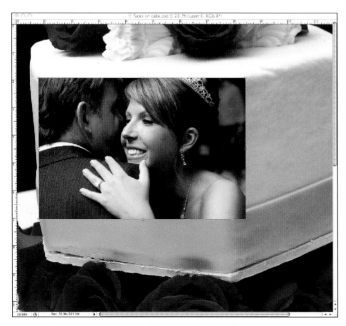

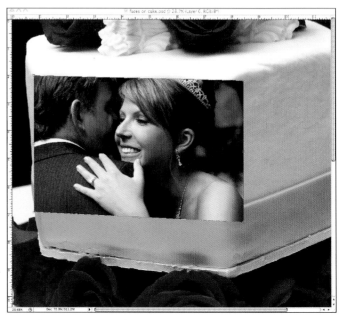

7-7. *The Father-Daughter layer scaled and positioned over the cake.*

7-8. *The perspective of the image is adjusted to coordinate with the receding plane of the cake.*

Press V to activate the Move tool. Click on the image of the father-and-daughter dance to activate it. Click and drag the image into the canvas. Rename this new layer "Father-Daughter." Hit Ctrl-T (Mac: Cmd-T) to Free Transform the image. Press and hold Shift (to maintain the original aspect ratio) while resizing the layer by dragging one of the corner boxes. Make the image slightly larger than the surface of the left side of the top layer of the cake, as seen in image 7-7. *Do not hit Enter yet.*

We now need to alter the perspective of this image so it will match the perspective of the cake surface it falls on. This is to make the image look as though it is truly printed on the cake. If we don't do this correctly, the image will violate our common sense—and we, as Photoshop users (and, in this case, illusionists) will not have created a successful illusion.

With the Free Transform active, right click on the Father-Daughter layer and select Perspective. Click and hold the edge box on the right and drag it downward. This creates a tilt, as if the viewer is seeing the image from an angle. Then, click and hold the lower left corner box and drag it upward. This will make the left edge shorter, creating the impression that it is receding from the viewer. Your work should look like image 7-8. If so, hit Enter to accept the Transform.

> If we don't do this correctly, the image will violate our common sense.

Soft Dropout

Now we have to hide the hard edges around the Father-Daughter layer. To do this, we will use a Layer Mask and a soft brush. As we've already done with some other examples in this book, we will start from a black Layer Mask in this case. This means we will bring the image back from nothing.

In the Layers palette, make sure the Father-Daughter layer is active. Then, press and hold Alt (Mac: Opt) and click on the Add Layer Mask icon at the bottom of the Layers palette. A black Layer Mask will now be attached to the Father-Daughter layer—and the image disappears.

We will now use our soft-brush skills to bring the image back with great subtlety. Hit B to activate the Brush tool. In the Options, set the brush diameter to around 300 pixels and make sure the opacity setting is around 70 percent. At the bottom of the Tools, make sure the foreground color is set to white.

Place your cursor in the middle of the Father-Daughter layer (hopefully you remember where it should be), then give it a click. The image reappears. Move the cursor around and click a few more times—but avoid showing the edge of the image. Reduce the brush diameter to 200 pixels and click a few more times on the center of the faces to make sure they are fully shown. If any edges were accidentally brought back, swap the foreground color to black (by pressing X) and paint them back out. When you're done, it should look like image 7-9.

7-9. Using a Layer Mask to create a soft dropout on the Father-Daughter layer.

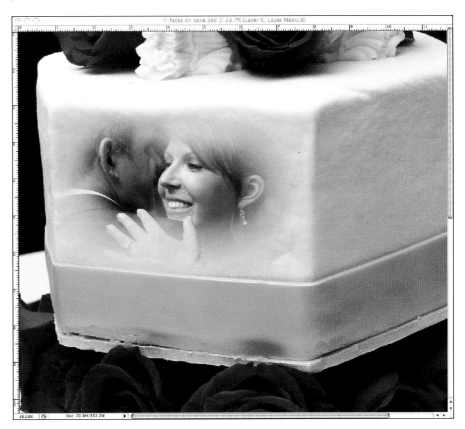

The Icing on the Cake

Although this image looks good on the cake, it does not persuade the viewer that it is actually part of the cake. To correct this, the Layer Blending Modes come to mind. If we use the right Layer Blending Mode, the texture of the cake will be visible below the overlaying image, making the image look more like it was actually part of the cake. Which Layer Blending Mode should we

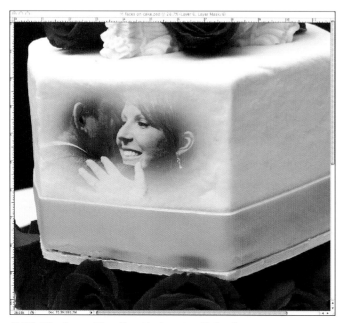

7-10. *The Layer Blending Mode set to Color Burn.*

7-11. *The Layer Blending Mode set to Screen.*

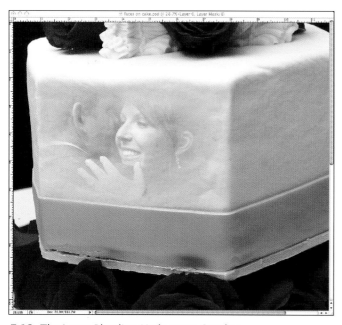

7-12. *The Layer Blending Mode set to Overlay.*

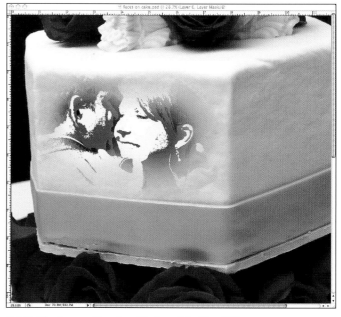

7-13. *The Layer Blending Mode set to Hard Mix.*

use? I am including screen shots of a few interesting options as a case study (see images **7-10** to **7-13**). Among all Layer Blending Modes, Overlay best preserves the image and the texture of the cake. In the Layers palette, click on the Layer Blending Mode pull-down menu (right under the Layer tab) and select Overlay.

Adding More Faces

Repeat the same procedures to bring the remaining images in to the other three cake surfaces. Now your montage will look like image **7-14**.

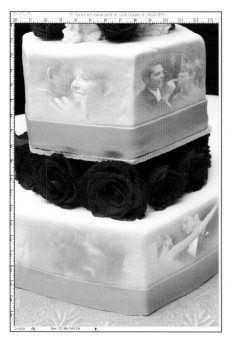

7-14. *The remaining images are added using the same techniques.*

A Soft Cake is a Good Cake

So far, our image looks fine except for one thing: the cake is too prominent. Although the cake is featured, the *faces* should really be the stars of the montage. We have to find a way to tone down the cake so it will not draw too much attention. To do this, we will use Smart Filters to soften the cake.

In the Layers palette, click on the Cake layer. Then, go to Filter > Convert for Smart Filters. Give it a few (or quite a few) seconds to work on it. When the hour glass is gone, you will see a special symbol on the Cake layer, as seen in image 7-15. This means that the Cake layer is now a Smart Object.

We will now use the Gaussian Blur filter to create the softened look. Go to Filter > Blur > Gaussian Blur. When the dialog box appears, set the Radius to 90 pixels and click OK. Now a progress bar will appear. (You see, there is always a catch when you use the newest and the best! The catch for using Smart Objects is that it takes longer to process them.) When the task is done, you will see a very blurry cake, as shown in image 7-16.

To tone down the blurriness, direct your attention back to the Layers palette. You will find a whole bunch of additions under the Cake layer, as seen in image 7-17. Meet the Smart Filter function—one of the most robust additions in Photoshop CS3. Using it, filters are applied parametrically (or nondestructively) to a layer. Because the image is not permanently changed, the filter can be re-edited or removed. Isn't that what a "filter" should behave like?

Now we will tone down the Gaussian Blur. In the Layers palette, on the right side of the Gaussian Blur, double click on the Adjustment icon (seen in image

7-17. *In the Layers palette, you'll see a bunch of additions under the Cake layer.*

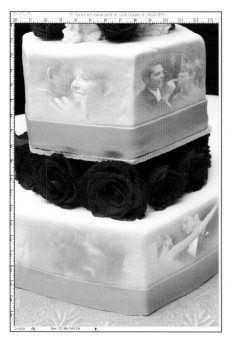

7-15. *The Cake layer is now converted to a Smart Object.*

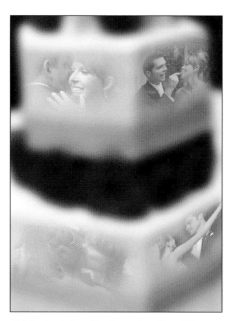

7-16. *Applying the Gaussian Blur filter results in a very blurry cake. We'll need to tone this down.*

7-18) to bring up the Adjustment dialog box. Again, you'll have to wait for the progress bar to move forward (Didn't I say something about the strings attached to using Smart Objects?). When the dialog box appears, set the opacity to 40 percent to reduce the effect of the Gaussian Blur.

7-18. The Adjustment icon.

The Results

Our cake is out of the oven! Does your taste like mine, as seen in image **7-19?**

7-19. The final image.

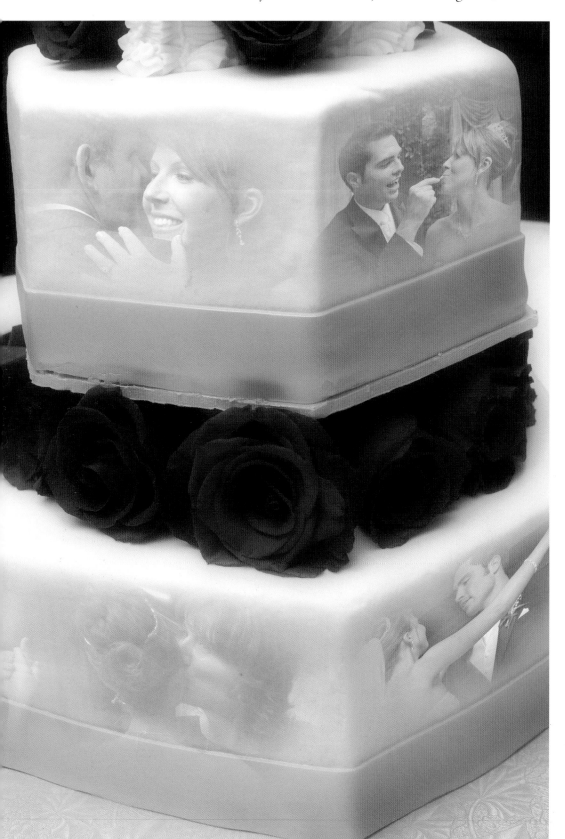

Emotions in Motion

COMPLEXITY LEVEL
High

TECHNIQUES INVOLVED
Soft-Brush Technique, Motion-Blur Effect, Liquify Filter, Sepia Toning, Selections/Layer Masking

8-1 to 8-6. The raw materials for our collage will be drawn from these images.

W̶e live in a world of vertical and horizontal lines. These cold frameworks represent our highly industrialized, technology-driven society. However, in the eyes of an artist—me, for example—they are boring. We have seen enough straight lines, so I want to avoid them in my work. You should have noticed by now that there aren't a whole lot of straight lines in the ex-

amples that appear throughout this book. This collage, in particular, is going to elaborate on that. We will take it one step further, though, by making it our objective to emphasize the sense of fluidity; we will make the collage "flow."

The Images

Have a look at images **8-1** to **8-6** (previous page). This series of vivid candid shots was taken at the first dance, the father-daughter dance, and the mother-son dance. The subjects' faces are overflowing with joy. Armed with these excellent images, we can design a postproduction strategy to elevate photojournalism into art. Read "What the Wise Man Says 10: The Importance of Being Real" (page 37) and "What the Wise Man Says 15: Garbage In, Garbage Out" (page 62) for the philosophies behind this creative process.

If you'd like to see what the collage will ultimately look like, flip to the end of the chapter. We will use five of the images to form a kind of flowing backdrop. Layer Masking, Motion Blur, and the Liquify filter will all be required in realizing that. Sepia toning will also be applied to the backdrop. I will show you how to achieve this parametrically (read "What the Wise Man Says 3: Regrettable Procedures *vs.* Nondestructive Procedures" on page 16). Finally, the full-length image of the couple dancing will be selected and placed, without sepia toning, in front of the backdrop.

Let's get started. If you'd like to follow along, download the practice files from Amherst Media's web site (see page 8).

Open the practice files, then go to Window > Arrange > Tile Horizontally so you can see all the images. Press Z to go to the Zoom tool, then check Zoom All Windows in the Options. Move the cursor to the active window, press and hold Alt (Mac: Opt) and click to zoom out until all of the images can be seen completely in their respective windows.

> We will use five of the images to form a kind of flowing backdrop.

Prepare the Canvas

Now we need a canvas. Go to File > New to create a canvas for our collage. Make it 20 inches wide and 13.5 inches high at 100dpi. Type "Emotions in Motion" in the Name field, then click OK. Again, this resolution setting will be good only for practice; you will need three times this resolution for print output.

This collage is going to have a black background, so press D to reset the background color to the default black. Hit Ctrl-Backspace (Mac: Cmd-Delete) to fill the background color to the currently active layer, the background.

Shall We Dance?

It's time to bring in the dancing figures. I am going to demonstrate this procedure on one of the five images we will bring in. The other four can be done in a similar manner.

A SOFT BRUSH IS A GOOD BRUSH

Looking through the examples in this book, you will see that the usage of Layer Masks is often coupled with the use of the Brush tool. When we use the Brush tool on a Layer Mask, we will almost always want a soft brush to hide the brush strokes. Compare images 8-7 to 8-9 to see brushes with different softness settings (or hardness settings, depending on how you look at it).

8-7 to 8-9. Brushes with different levels of softness.

If these brush settings were applied when using the Brush tool on a Layer Mask, you can see that 8-9 would provide the softest dropout. This brush has a hardness setting of 0 percent—brushes do not get any softer than this. But what if we desired something even softer than the softest brush?

Here is the solution: use less opacity to start with. Drop it to around 70 percent and apply the first stroke. Then reduce the brush diameter and apply a second stroke toward the center of the first brush stroke. Opacity accumulates. With the first stroke, you get a 70 percent whiteness (which is of course, a gray). When you apply a second stroke on top of the first stroke, you get 70 percent + (70 percent x 30 percent) = 91 percent. On the second click, we are applying 70 percent whiteness to the remaining 30 percent blackness, so the center will be nearly pure white.

8-10. Using the Brush tool on a Layer Mask at a reduced opacity setting allows the creation of softer transitions than even the softest brush setting will permit.

When the second stroke is applied with a smaller brush, it thickens the transition between white and black. Have a look at 8-10. It looks even softer than 8-9, doesn't it?

Press V to activate the Move tool. Then, click on image 8-4 (the image of the groom dipping the bride) to activate it. Click and hold on the image, then drag it into the Emotions in Motion canvas. Name the new layer "Dipping."

Hit Ctrl-T (Mac: Cmd-T) to Free Transform the new layer. Press and hold Shift to maintain the original aspect ratio (to avoid distortion) while you drag on one of the corner boxes to resize the image. The height of the dancing figures should be about half of the height of the canvas. When you're done, use the Move tool to drag the Dipping layer to the top right corner of the canvas.

Now we will use the soft-brush technique to paint on a Layer Mask, yielding a very soft dropout around the dancers. To learn more about this technique, read "What the Wise Man Says 20: A Soft Brush is a Good Brush."

In the Layers palette, make sure that the Dipping layer is active. Take a mental picture of the positions of the faces and the edges of the image in the Dipping layer. Then, press and hold Alt (Mac: Opt) while clicking on the Add Layer Mask Icon at the bottom of the Layers palette. The image disappears.

Press B to activate the Brush tool. In the Options, make the brush diameter 250 pixels, the hardness 0 percent, and the opacity 70 percent. At the bottom of the Tools, make sure the foreground color is set to white.

Starting from the position of the bride's head, click and hold, then move the brush downward. Stop before the circle of the brush gets close to the edge of the image. Repeat the same stroke from the position of the groom's head. You should see a subtle image of the dancing couple reemerging. (If you accidentally revealed some edges, hit X to swap the foreground color to black and paint out the edges to mask them.)

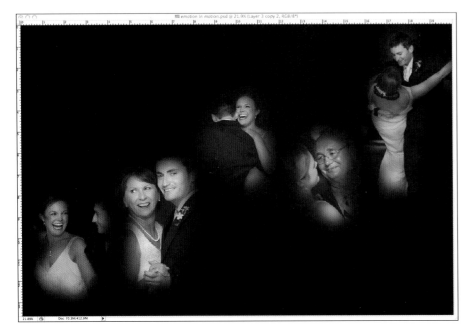

8-11. The state of the collage so far.

Now we will make sure that the faces are in full contrast. Reduce the brush diameter to 150 pixels and click on the faces of the couple (or any other spots that you think should be prominent). When you're done, there should be a very nice, soft dropout around the image.

Repeat the same procedures for the remaining background images (skipping 8-4, the full-length image of the bride and groom dancing that will appear in the foreground of our collage). When you're done, the collage should look like image **8-11**.

Make Them Flow

Now we are going to add motion blur to the five background images. First, though, we are going to duplicate all of them.

In the Layers palette, click on the top layer. Press and hold Shift, then click the bottom layer (but not the Background layer). Now, the image layers for all five images will be selected. Click and drag these five images onto the Create a New Layer icon at the bottom of Layers palette. Doing this will create duplicates of all five layers.

Right click on any one of these five new layers and select Merge Layers. The five layers will now all be in one layer. Rename this layer "Motion." This layer is where we will create the motion blur effect.

With the Motion layer active, go to Filter > Blur > Motion Blur. In the dialog box, set the angle to 25 degrees and the distance to 330 pixels and click OK. The angle setting defines the direction of the motion blur. The distance setting determines the length over which the blur will travel. I choose to make it 25 degrees to make the flow follow along in the general direction of how the background images are arranged.

Right click on any one of these five new layers and select Merge Layers.

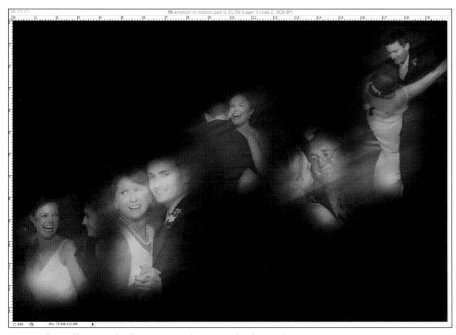

8-12. The collage with the Motion Blur on a duplicate layer at 80 percent opacity.

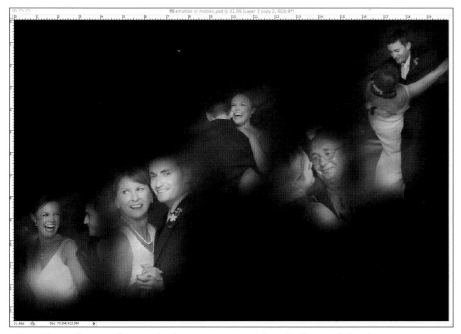

8-13. The collage so far—with sharpness restored to the faces of the dancers.

When the Motion Blur is applied, the opacity of this layer will naturally be reduced without actually changing the opacity setting in the Layers palette. But, although you can see through it, the blur is still too strong. We need to tone it down so that the sharp images retain their prominence. With the Motion layer still active, go to the Layers palette and reduce the opacity setting to 80 percent. Now the collage will look like image 8-12.

Reducing the opacity toned down the blur a bit, but we still want the faces to be more visible. At the bottom of the Layers palette, click on the Add Layer Mask icon. The Motion layer now has a white Layer Mask. The Layer Mask is active right after its creation.

Press B to activate the Brush tool. Set the brush diameter to around 200 pixels and the opacity to 60 percent. At the bottom of the Tools, make sure the foreground color is set to black. Place the circular cursor of the Brush tool over the faces of the dancers, one at a time, and click—but do not hold the click! The Motion Blur layer will become more transparent on those spots. If you want to see even sharper faces, click a few more times on the same spot to accumulate more black on the Layer Mask.

The purpose of these steps is to bring the faces back to sharpness while maintaining the Motion Blur filter's effect on the surroundings. When you are done, the collage should look like image 8-13.

Our aim is to create an organic, flowing look. The straight movement from the Motion Blur filter is not entirely organic. We can do something to add "turbulence" to the motion so it looks more natural. We will accomplish this with a little help from the Liquify filter. (Warning! Don't try this if you have

a computer with subpar performance; running the Liquify filter requires serious computing power. Your wait for the Liquify filter to finish running will feel eternal if your computer does not have sufficient muscle. Read "What the Wise Man Says 21: Photoshop Users Mustn't Be Cheapies," if you want to gain some insight on the importance of good equipment.

In the Layers palette, click on the image thumbnail of the Motion layer to activate it—be sure to click on the image layer itself, not the Layer Mask. **Go to Filter > Liquify.** After some wait, you will be brought into a large, complicated-looking dialog box like the one seen in image **8-14**. Once you are in the dialog box, the preview will take a while to load. You can watch the progress of that at the lower left corner of the box. It is highly recommended that you suppress your excitement and *not* do anything before the preview is fully loaded. Doing something sooner can cause added delay.

8-14. The Liquify filter's dialog box.

As you can see, the default preview in the Liquify dialog box shows only the current layer in front of a checkerboard pattern (which means "nothing is there" in Photoshop). In some cases, this makes it hard to visualize the effect—and this collage is one of those cases. To rectify the situation, **go to the lower right corner of the Liquify filter's dialog box and check Show Backdrop. In the Mode pull-down menu, select Behind.** Now the preview should look like image **8-15**.

8-15. *Here's the complete image preview in the Liquify filter dialog box.*

8-16. *The Twirl tool.*

With the other layers showing, we can do our job with ease. Now we will add some waves to the motion blur. In the Liquify dialog box, activate the Zoom tool and zoom in to the top right image, the Dipping layer. On the left side of the dialog box, click on the Twirl tool, as seen in image **8-16**. On the right side of the dialog box, enter a brush diameter of 100 pixels. Enter values of 50 for the brush density, brush pressure, and brush rate.

Choose an area of the motion blur with clear band (striped) patterns. Place the circular cursor on it. Then click, hold, and move in a few short and random strokes in the vicinity. Watch how the "turbulence" appears, as you can see in the circled areas of image **8-17**.

Repeat these steps on other areas of the motion blur, keep the effect random by varying the strokes, brush diameter, and directions (hold Alt [Mac: Opt] to

8-17. *Notice how "turbulence" begins to appear in the circled areas.*

apply the Twirl tool counterclockwise). When you are done, the collage should look like image **8-18**. The flow of the Motion Blur filter's effect is now even more "flowy."

Convert to Sepia Tone

Now, let's give the backdrop a sepia-tone look. This will help reduce the prominence of the backdrop, letting the dancing couple image (not yet incorporated) stand out. This is a case of reducing elements. For some insight on this design philosophy, read "What the Wise Man Says 22: The More the Merrier? Not!" (below).

8-18. The image so far.

The sepia-toning technique I am going to introduce here is very easy and very rewarding. In the Layers palette, make sure the current active layer is the top layer. At the bottom of the Layers palette, click on the Create New Fill or Adjustment Layer icon and choose Hue/Saturation. When the Hue/Saturation dialog box (CS3 and earlier) or Adjustments palette (CS4 and later) appears, drag the saturation slider to the left so the value is about –50. This will take most of the colors away. In CS3 and earlier, hit OK before moving on.

WHAT THE WISE MAN SAYS 22

THE MORE THE MERRIER? NOT!

More is not better in a montage—well, actually, more is not better in *all sorts of art media*. When too many elements are introduced into a body of work, chaos can ensue. Conversely, if you take an overly minimalist approach, you run the constant risk of being called lazy or uninspired. The level of complexity in your images and designs needs to be balanced. The following factors affect the complexity, with the left side being more complex and the right side being less complex:

> Very ColorfulMonochromatic
> Sharp .Soft
> High Contrast .Low Contrast
> More Details .Fewer Details

By controlling these factors, you can attune the complexity right to the sweet spot. Sometimes, this means limiting a certain aspect of the montage, just to make sure a more important component stands out as the visual focal point.

Next, click on the Create New Fill or Adjustment Layer icon again. This time, choose Color Balance. When the dialog box (or Adjustments palette) appears, drag the Cyan/Red slider to the right to around the −35 value. Drag the Yellow/Blue slider to the left to around the 35 value. For CS3 and earlier, hit OK to complete this step. This adjustment will add lots of red and yellow. Combining these two adjustment layers, we get sepia toning. By keeping a slight hint of the original colors, the image looks more like a faded color photo.

And Now, It is My Pleasure to Introduce Mr. and Mrs . . .

Now, let's bring the dancing couple into the canvas. We will make a precise selection of them so we can cut off the real background behind them. As we have in some other examples, we will bring the image in with the original background, then we will mask the couple to separate them from it. (Please read "What the Wise Man Says 16: Always Keep More Than You Need" on page 63 for more on this.)

To begin, activate the Move tool by pressing V. Click and drag the full-length image of the couple dancing (8-3) into the Emotions in Motion canvas. Rename this new layer "Couple."

Now we will make selections of the bride and groom. These selections will later be converted into a Layer Mask to remove the original background. For extra tips on using the Magnetic Lasso, read "What the Wise Man Says 8: The Magnificent Magnetic Lasso" on page 30.

Zoom in to the lower left corner of the bridal dress—approximately as seen in image 8-19. Zooming in too much or too little will make the selection process awkward.

Now, activate the Magnetic Lasso tool. Start the selection by clicking on the lower left corner of the dress. Move the cursor carefully upward along the edge of the dress. Anchor points, denoted by small boxes, will be placed automatically along the selection.

If it becomes necessary to undo any misplaced anchor points, back up the cursor to the area before the misplaced selection starts and retrace it on the correct border. This time, though, force anchor points to appear in the correct places by clicking the mouse. The forced anchor points should be placed often enough that the selection does not jump to a wrong border. If anchor points are placed in the wrong spots, hit Backspace (Mac: Delete) to cancel the anchor points one at a time. (Read "What the Wise Man Says 8: The Magnificent Magnetic Lasso" on page 30 for more on this.)

Whenever your cursor is about to run out of the window, press and hold the Space bar to change to the Pan tool on the fly. Then, click and drag the image to reveal the areas you need to work on next. Release the Space bar to return to the Lasso tool. (Don't ever attempt to touch those scroll bars to pan! You are

8-19. *Zooming in to begin the selection process.*

going to make a mess. Do not pull the cursor out of the window to use the automatic pan, either. It is quite likely to cause you trouble.)

Continue on with tracing upward, panning when required. When you reach the bride's hair, skip this area by overselecting it (selecting a little extra area around the hair). We will deal with her hair later when we have a Layer Mask. Overselect the groom's hair as well, forcing anchor points as needed.

When you reach the origin point, where you began making your selection, watch for a tiny circle at the lower right of the cursor. This denotes closing the selection. Click to close the selection.

Now we need to cut some holes. These are areas of the background that are enclosed by the body parts or clothing of the couple. To do this, activate the Magnetic Lasso tool. In the Options, click on the Subtract from Selection mode, as seen in image **8-20**.

8-20. *Choosing the Subtract from Selection mode for the Magnetic Lasso tool.*

Using the same method as in the previous steps, trace the space between the groom's legs. Be careful not to cut the dress away. When the tracing approaches the origin and a tiny circle appears next to the cursor, click to close the selection.

As you can see, there are now two levels of "marching ants" on the selection. The one on the edge of the couple denotes where the selection begins. The one that we just made denotes where the selection ends. So this is a "hole" in the selection.

We have finished the selection process. The next thing to do is to refine it before we turn it into a Layer Mask.

Refine the Selections

Make sure your read "What the Wise Man Says 7: The Fuzzy Reality" (page 27) before you start on this procedure. It is always best to know *why* before you know *how*.

With the selections made from the previous steps active, go to Selection > Refine Edge. Adjust all the settings to 0 and choose the black background, as seen in image **8-21**. Set the Feather radius to 2.0 pixels and the Contract/Expand to −50 percent. Click OK to accept the settings in the Refine Edge dialog box.

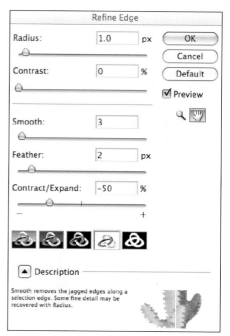

8-21. *The settings in the Refine Edge dialog box.*

In the Layers palette, make sure the Couple layer is activated and click on the Add Layer Mask icon. The original background disappears—well, mostly. The hair areas where we overselected in the previous steps will remain. If you zoom in and pan around, you will find that the edges of the dancing couple are softly cut.

Mask the Hair

The selection of the hair in this image is rather simple. Zoom in to the hair and you will find the styles are pretty well defined without any loose strands or loops. My soft-brush technique can handle this case very well.

WHAT THE WISE MAN SAYS 23

LAYER MASK: THE MASTER OF SHOWING AND HIDING

A layer can have a Layer Mask, which is in charge of showing the layer or hiding the layer. The showing and hiding is made possible by painting the Layer Mask white or black. White shows; black hides.

Throughout this book you've seen lots of examples of using Layer Masks to show and hide. Here's an example from this chapter. Look at image **8-22**. On the left, we have the original image with a backdrop that we would like to get rid of. After applying a Layer Mask, as illustrated in the middle, we get the image on the right—without the backdrop.

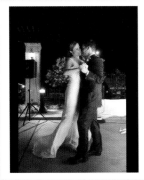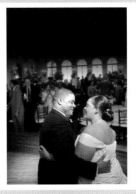

8-22. Applying a Layer Mask to remove the background.

Layer Masks can also be used on Adjustment Layers to localize their effect. Take the example below from project 9. The left side of image **8-23** shows an image turned very dark by an Adjustment Layer set to Levels. In the middle, you can see a gradient pattern applied to the Layer Mask for the Adjustment Layer. On the right side, the darkened area is confined to only the white area of the Layer Mask. The gray area partially canceled the effect of the Levels adjustment.

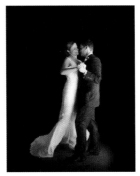

8-23. Layer Masks can be used in combination with Adjustment Layers.

Layer Masks are the key for robustness in your compositions. Once you have mastered them, you should never use the Eraser tool again. Pixels hidden by a Layer Mask can be brought back at any time; erased pixels are tossed into oblivion, never to return.

Press B to activate the Brush tool. Use [and] to adjust the brush diameter to 15 pixels. Use Shift-[and Shift-] to adjust the hardness of the bush to 0 percent. At the bottom of the Tools, set the foreground color to black. In the Options, set the opacity to 100 percent and the flow to 100 percent. In the Layers palette, make sure the Layer Mask on the Couple layer is active.

The first task is to get rid of the current hard edge as a result of our overselection in the hair area. Let's do the groom's hair first. Place the cursor on the hard edge near the forehead. Click and hold to paint. Move along the edge toward the other side of the head. Release the click and stop painting if you feel your hand is not steady. Reposition the cursor and start over. Repeat these steps until all the hard edges are masked out. Get as close as possible to the hair without touching any hairs.

Now, we are going to mask out the edges of the hair to eliminate the background. In order to create the gradual dropout at the edge, we will use a lower opacity. This also reduces the speed of the brush, so you can watch what you are doing—and avoid overdoing it.

In the Options, change the opacity setting to 75 percent. With the circle of the brush falling just slightly onto the hair, click and hold to paint one area at a time. In some

areas, where hair strands are sticking out, use sporadic clicks in between the strands. Repeat these steps until the halo from the original background is invisible.

Due to the simplicity of this image, we will not need further steps to refine the selection of the hair. Just repeat the same procedure for the bride's hair.

Keep the Feet on the Ground

Now we will place the couple at a good spot. Hit Ctrl-T (Mac: Cmd-T) to Free Transform the Couple layer. Adjust their size and place them in the right spot so the collage will look like image 8-24.

8-24. Scaling and positioning the couple.

But wait—something doesn't look right. The dancing couple seems to be floating in midair. Have a look back at the original image on page 99. They were dancing on a pretty dark background with subtle shadows. Why don't we bring back the original floor, at least to a certain degree, so they can keep their feet on the ground?

Press B to activate the Brush tool. In the Options, set the opacity to 30 percent. Use [and] to adjust the brush diameter until it is about 300 pixels. At the bottom of the Tools, make sure the foreground color is set to white. In the Layers palette, make sure the Layer Mask of the Couple layer is activated.

Place the circular cursor at their feet and make a few single clicks. The ground will appear. We do not want a full opacity on this—just a hint that they are standing on something.

8-25. Restoring some of the floor helps ground the couple in the image.

8-26. The Layer Mask created for the dancing couple.

If too much ground shows (or some unwanted edge or object is revealed) hit X to swap the foreground color to black. Change the opacity to 100 percent and paint to mask out the problem areas. *This is very important:* while masking out with black, stay away from the dancing figures. If you paint black on the dancing figures, you will ruin the delicate selection we made earlier.

If you do this step correctly, the couple's footing will look like image **8-25**. If you Alt-click (Mac: Opt-click) on the Layer Mask of the Couple layer you will see the Layer Mask alone, as in image **8-26**. As you can see, our last few clicks on the ground created some gray area on the Layer Mask, resulting in semi-transparency.

The Results

8-27. The final collage.

Our collage is done. Does your work look like mine, as seen in image **8-27**?

PROJECT 9
Light and Shadow

COMPLEXITY LEVEL
Low

TECHNIQUES INVOLVED
Adjustment Layers, Layer Masks, Creative Typing

Here is an example of simplicity that goes a long way. The secret is having a great image to start with. Look at image **9-1**. This is a shot of the first dance. Near dusk, light was cast on the couple through a window. Their expressions and body language formed a wonderful narrative. Spectators, nicely (and conveniently) out of focus, provided a perfect backdrop and context for the composition. Basically, all the elements are all there. We will just add further refinement and creative typing to turn this image into an album cover.

Prepare the Canvas

If you want to follow along, you may download the practice image file from Amherst Media's web site (see page 8). Open the practice file.

Now, we need a canvas. Go to File > New to create a canvas for our collage. Make it 9.5 inches wide and 14 inches high at 100dpi. Type "Light and Shadow" in the Name field, then click OK. (Again, this resolution setting is good only for practice purposes. You would need three times the resolution for output.)

9-1. The key to this simple technique is starting with a great image.

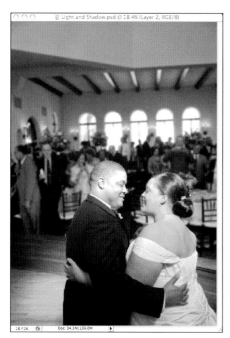

9-2. *The image with the scaled photograph in place.*

9-3. *Adjusting the white-point slider in the Levels dialog box. The left image shows the dialog box for CS3 and earlier. The right image shows the Adjustments palette for Photoshop CS4 and later.*

Bring in the Image

Press V to activate the Move tool. Click on image **9-1** if it is not activated. Click and drag the image into the Light and Shadow canvas. In the Layers palette, re-name this new layer "First Dance."

Hit Ctrl-T (Mac: Cmd-T) to Free Transform the First Dance layer. Drag the First Dance layer to the top left corner of the canvas and place the corner of the layer right on the corner of the canvas.

Holding Shift to maintain the original aspect ratio, click and drag the lower right handle to enlarge the First Dance layer so that it covers the canvas completely. When you're done, the collage should look like image **9-2**.

Set the Stage for the Title

We will use text in a light color for the title, which will be their names. In order to make the title stand out, we will use Levels and a Layer Mask to create a darker area at the top of the image. This darker area will also conceal the ceiling, where we do not want viewers' eyes to linger.

In the Layers palette, make sure the First Dance layer is active. At the bottom of the the Layers palette, click on the Create New Fill or Adjustment Layer icon and choose Levels. In the Levels dialog box (CS3 and earlier) or Adjustments palette (CS4 and later), drag the white-point slider for the Output Levels to the left until its value is around 35, as seen in image **9-3**. In CS3 and earlier, hit OK to complete this step.

The collage now looks very dark, as in image **9-4** (next page). This is because the histogram of the image is now compressed to a small range—it's almost black. (*Note:* To learn about histograms and Levels, read "What the

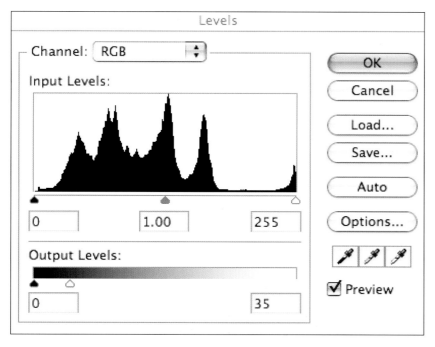

9-4. With its histogram compressed, the image is very dark.

9-5. Here, the beginning and ending points of the Gradient are indicated.

Wise Man Says 13: Profiling the Brightness with Histograms" [page 55] and "What the Wise Man Says 17: Using the Histogram as a Gauge to Adjust an Image" [page 73].)

We will use the Layer Mask on the Levels 1 Adjustment Layer to limit its effect to just the top portion of the collage. In order to create a soft look, we will use the Gradient tool.

In the Tools, click on the Gradient tool to activate it. If the Gradient tool is not in sight, click and hold on the Bucket tool until the pull-down menu appears. Then, choose the Gradient tool. (*Note:* Having many tools share the same address helps conserve precious real estate in the Tools. While most of the roommates are of similar natures, the Bucket and Gradient tools are not. The fact that they are forced to live under one roof might cause some confusion.)

In the Layers palette, click on the Layer Mask for the Levels 1 Adjustment Layer to activate it. (You should see a frame around the symbol of the Layer Mask when it's active.)

Having many tools share the same address helps conserve precious real estate in the Tools.

For this image, we want the

black to be at the bottom and

the white to be at the top.

At the bottom of the Tools, check to see whether the foreground color is black or white. Why does it matter? Look at image **9-5**. The beginning and ending points of the gradient are indicated here. The Gradient tool is applied by clicking and holding on the first point, then dragging and releasing on the second point. The order of these two points, however, depends on the order of the foreground and background colors. For this image, we want the black to be at the bottom and the white to be at the top. Therefore, if black and white are the foreground/background colors (respectively), click the lower point first, then drag upward. If white and black are foreground/background colors (respectively), click the top point first then drag downward.

Now, the collage will look like image **9-6**. If you Alt-click (Mac: Opt-click) on the Layer Mask symbol for the Levels 1 Adjustment Layer in the Layers palette, you will see a gradient pattern like the one in image **9-7**. The effect of the Levels 1 Adjustment Layer is canceled by the black at the bottom but is in full power at the top. In between, the gradient pattern gradually unleashes the power of the Levels 1 Adjustment Layer.

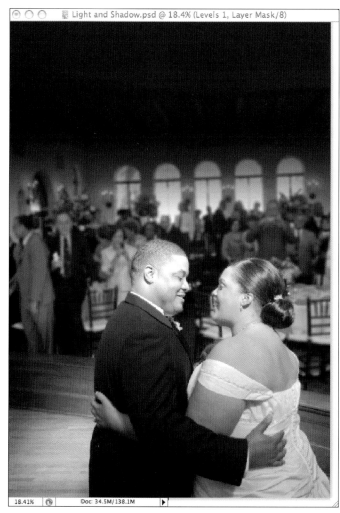

9-6. The collage adjusted by a gradient on the Layer Mask.

9-7. The Layer Mask for the Levels 1 layer.

Add the Title

I love to use nice fonts. My creations can be greatly enhanced by works of great calligraphers. Plenty of fonts are free, or some fancy/new fonts can be purchased. For this design, I am using a font called Ambience BT Swash from www.myfonts.com. It is an elegant cursive script that matches the collage well. If you do not have this particular font, find another font that you think would work well.

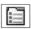

9-8. The symbol for the Character palette.

Press T to activate the Type tool. In the Options, click on the fonts pull-down menu and select Ambience BT Swash (or your choice of font). On the right side of the Options, click on the symbol for toggling the Character palette on/off. The symbol looks like image 9-8.

In the Options, click on the Set Text Color symbol (currently, it is probably white or black). When you do this, the Select Text Color dialog box will appear. We will not use this dialog box. Instead, move your cursor to the image. Note that it turns into an Eyedropper tool. Click on a highlight on the dancing couple's faces and you will see the same light orange color appear in the Select Text Color dialog box. Click OK. By selecting a color from their skin for the text, we can be sure that the type color will match the warm look of the image.

9-9. The settings in the Character palette.

In the Character palette, set the leading (the distance between lines) to 20. Leave the other settings at their defaults, as seen in image 9-9.

Place your cursor over the image, click, then type "Lauren" and press Enter. Type several spaces, type "and", then hit Enter. Type several spaces, then type "Courtney". When you're done, it will look like image 9-10. Hit Ctrl-Enter (Mac: Cmd-Return) to accept the typing.

To refine the look, I would like to reduce the size of the "and", making the names stand out more. With Type tool still active, click immediately to the left of "and" and drag your mouse to the right to select (highlight) the word. In the Options, change the font size to 20 points. Hit Ctrl-Enter (Mac: Cmd-Return) to accept the typing. Now, the text will look like that seen in image 9-11.

Let's add an Outer Glow Layer Style to the type to give it some further accentuation. In the Layers palette, make sure the Type Layer is active. Then, go to the bottom of the Layers palette and click on the Add a Layer Style Icon. Choose

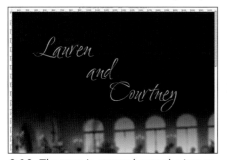

9-10. The type is entered over the image.

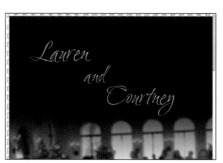

9-11. The size of the "and" is reduced to leave the emphasis on the couple's names.

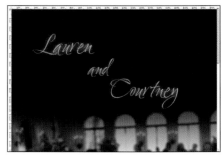

9-12. The image with the Outer Glow Layer Style applied to the text.

Outer Glow. In the Outer Glow dialog box, set the opacity to 50 percent, accept the default yellow color (this is rarely acceptable, but here it works). Set the size to about 20 pixels and click OK. When you're done, the type should look like that in image **9-12**.

The Results

We have finished the collage. Does your work look like mine, as seen in image **9-13**?

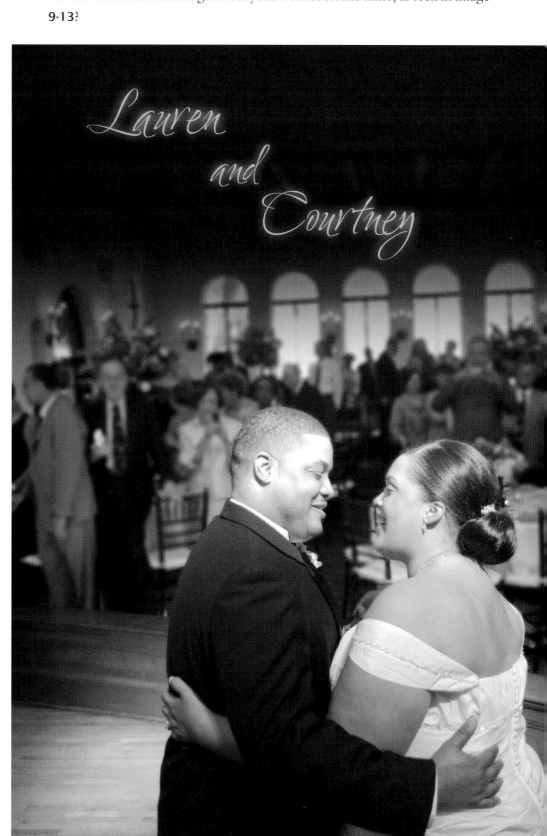

9-13. The final collage.

Mirror, Mirror, on the Wall

COMPLEXITY LEVEL
Medium

TECHNIQUES INVOLVED
Soft-Brush Technique, Layer Masks, Layer Blending Modes

Photographing into a mirror is always fun. It offers an interesting composition of the reflected image and the objects around the mirror, but it also serves a practical purpose during the shoot. During the chaotic process of the pre-ceremony preparations, the room is often too small to maneuver comfortably. Shooting into the mirror instantly provides a different perspective and a longer visual distance to work with.

In this project, we will use three images from the pre-ceremony preparations (images **10-1** to **10-3**). One was shot into a mirror where we see a happy bride. The others depict different memorable moments. We will work them into a montage.

If you would like to follow along, you may download the practice files from Amherst Media's web site (see page 8). Alternately, you can certainly use your own images that are of a similar nature.

10-1 to 10-3. The original images for this montage.

Start by opening the practice files. Go to Window > Arrange > Tile Horizontally so you can see all of the images. Press Z to go to the Zoom tool, then check Zoom All Windows in the Options. Move the cursor to the active window, press and hold Alt (Mac: Opt) and click to zoom out until all of the images are completely visible in their windows.

Prepare the Canvas

Now we need a canvas. Go to File > New to create a canvas for our collage. Make it 20 inches wide and 13.5 inches high at 100dpi. Type "Mirror, Mirror, on the Wall" in the Name field, then click OK. (Again, this resolution setting is good only for practicing on screen. For print output, you'd need three times this resolution.)

Expand the Wall

The wall area around the image of the bride in the mirror is not large enough to be used as a backdrop for our collage. We will need to enlarge it. First, though, let's bring in the image.

Press V to activate the Move tool. Click on the mirror image if it is not active, then drag it into the Mirror, Mirror, on the Wall canvas. In the Layers palette, rename the new layer "Mirror."

Hit Ctrl-T (Mac: Cmd-T) to Free Transform the Mirror layer. Hold Shift to maintain the original aspect ratio while clicking and dragging on a corner handle to enlarge the Mirror layer. Make the height of the mirror almost as high as the canvas. Hit enter to carry out the Free Transform. Next, click on the Mirror layer and drag it into place on the canvas, as seen in image **10-4**.

> Make the height of the mirror almost as high as the canvas.

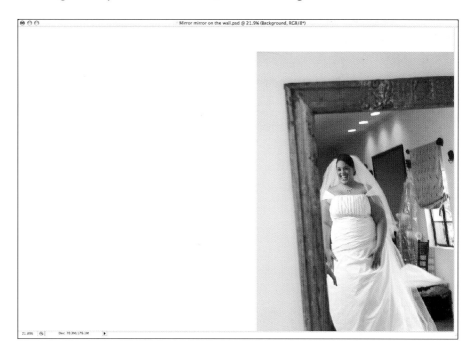

10-4. The Mirror layer is positioned on the right side of the blank canvas.

Now the white Background layer needs a paint job. To do this, we will sample a color from the existing wall. Notice that the brightness on the wall has some slight variations. We should pick from an average spot. The area near the top left corner of the mirror frame would serve that purpose.

Press I to activate the Eyedropper tool. Click on the wall area of the Mirror layer, near the top left corner of the mirror frame. At the bottom of the Tools, notice that the color of the wall is loaded as the foreground color.

In the Layers palette, click on the Background layer to activate it. Then, press Alt-Backspace (Mac: Option-Delete) to fill the foreground color into the Background layer. The montage should now look like image **10-5**.

10-5. The background wall now has some color, but it doesn't blend seamlessly.

The real wall and the "digital" wall do not blend seamlessly; the slight variations in brightness on the wall set it apart from the solid color on the "digital" wall. We will use the soft-brush technique to make the difference less noticeable. In the Layers palette, click on the Mirror layer to activate it. At the bottom of the Layers palette, click on the Add Layer Mask icon to give the Mirror layer a Layer Mask.

Press B to activate Brush tool. Use the [and] keys to adjust the brush diameter to 200 pixels. Use Shift-[to adjust the hardness of the brush all the way down to 0 percent—as seen in image **10-6**. In the Options, make sure the opacity is set to 100 percent.

10-6. Adjust the brush size to 200 pixels.

At the bottom of Tools, make sure the foreground color is set to black. If it's not, press X to swap the foreground and background colors. (*Note:* When a Layer Mask is activated in the Layers palette, the foreground/background colors are always set to black and white.)

Place your cursor on the edge of the Mirror layer, then click and hold as you move the cursor along the edge to paint. The edge disappears. Paint to cover all the edges. If done correctly, the edge of the real wall will be invisible, as in image **10-7**. Alt-click (Mac: Opt-click) on the Layer Mask for the Mirror layer and you will see it looks like image **10-8**. The gradual change between white and black conceals the difference between the real wall and the "digital" wall. (Read "What the Wise Man Says 20: A Soft Brush is a Good Brush" [page 101] to gain some insight on the soft-brush technique.)

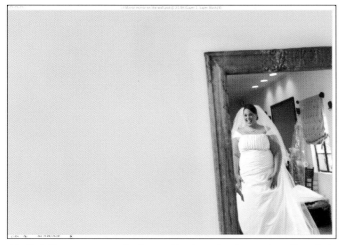

10-7. *Adjustments to the Layer Mask make the real wall and the "digital" wall blend seamlessly.*

10-8. *The Layer Mask for the Mirror layer.*

How a Bride was Made

Now we are ready to place other images. Press V to activate the Move tool, then click on the image of the bride's dress being buttoned and drag it into the canvas. Rename this new layer "Buttons." Press Ctrl-T (Mac: Cmd-T) to Free Transform the Buttons layer. Hold Shift (to maintain the aspect ratio) while you click and drag on a corner box to enlarge the layer. Make the image as tall as the height of the canvas. Finally, use the Move tool to place the image on the left side of the canvas, as seen in image **10-9**.

We will now use the soft-brush technique to give the Buttons layer a very soft dropout on the right edge of the image. We will start with a black Layer Mask this time. In the Layers palette, make sure that the Buttons layer is active. Then, hold Alt (Mac: Opt) while clicking on the Add Layer Mask icon at the bot-

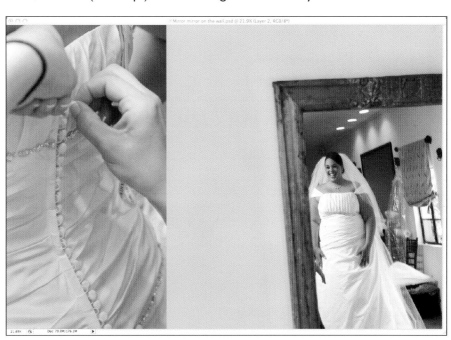

10-9. *The second image is placed on the canvas.*

tom of the Layers palette. A black Layer Mask will be added—and the Buttons image disappears.

Press B to activate the Brush tool. At the bottom of the Tools, make sure the foreground color is set to white. If it's not, press X to swap the foreground and background colors. In the Options, set the opacity to 70 percent. Use the [and] keys to adjust the size of the brush to 500 pixels. Press Shift-[to adjust the brush hardness to 0 percent.

Place the cursor where the buttons should be (they are now invisible) and click. Move up and down and click a few times. Don't get too close to the edge or overlap the clicked areas.

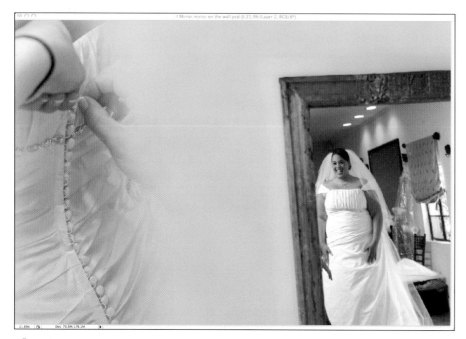

10-10. The Buttons layer has a very soft dropout.

10-11. The Layer Mask for the Buttons layer.

You can see the dress and the buttons now, but they are not in full contrast because the Layer Mask has only 70 percent white applied to it with each click. Hit [to reduce the brush diameter to 400 pixels, then click along the buttons a few times. Overlap the clicked areas to make sure the Buttons are in full contrast. When you're done, the Buttons layer should have a soft dropout, as seen in image **10-10**. The Layer Mask would look like image **10-11**.

Now, we will apply a Layer Blending Mode to make the image monochromatic. In the Layers palette, click on the Layer Blending Mode pull-down menu (immediately under the Layers tab) and choose Luminosity. Now the montage should look like image **10-12**. To learn more about Layer Blending Modes, read "What the Wise Man Says 12: Layer Blending Modes are Full of Surprises" on page 52.

10-12. *Changing the Layer Blending Mode to Luminosity makes the Buttons layer monochromatic.*

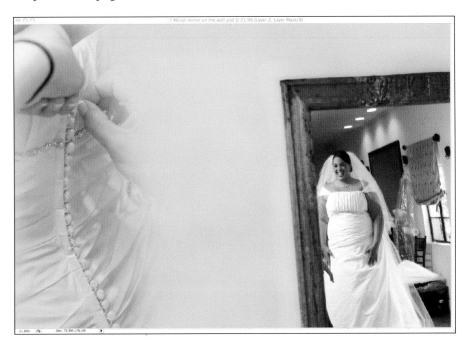

Now we will bring the headshot of the bride. Press V to activate the Move tool, then click and drag the image into the canvas. Rename the new layer "Bride."

If you do not have Rulers around the canvas, hit Ctrl-R (Mac: Cmd-R) to activate them. Then, press Ctrl-T (Mac: Cmd-T) to Free Transform the Bride layer. Hold Shift to maintain the aspect ratio while you click and drag a corner box to adjust the size of the layer. Make the bride's head about 7 inches tall, measuring it against the vertical ruler on the left side of the canvas.

Again, we will create a soft dropout using the soft-brush technique. Press and hold Alt (Mac: Opt), then click on the Add Layer Mask icon at the bottom of the Layers palette. A black Layer Mask is added to the Bride layer and the image disappears.

Press B to activate Brush tool. In the Options, set the opacity to 70 percent. Use the [and] keys to adjust the size of the brush to 500 pixels. Press Shift-[to

adjust the hardness of the brush down to 0 percent. At the bottom of the Tools, make sure the foreground color is set to white. If it's not, press X to swap the foreground and background colors.

Place the circular cursor where the bride's (now invisible) face should be and click. Moving up and down, click a few times. Do not get too close to the edge of the image or overlap the clicked areas.

10-13. *The bride's portrait is brought into position.*

The face of the bride will emerge, but not in full contrast. This is because the white on the Layer Mask it only at 70 percent. Use [to reduce the brush diameter to 400 pixels. Click on the face, neck, and necklace a few times. Overlap the clicks to make sure the important areas are shown in full contrast. (The Layer Mask in the overlapping clicked areas has accumulated 70 percent white a few times, so these areas are virtually white.) The bride's image should have a very soft dropout.

Finally, Press V to activate the Move tool and position the bride's image as seen in image 10-13.

The Results

We are done. Does your work look like mine, as seen in image 10-14?

10-14. *The final montage.*

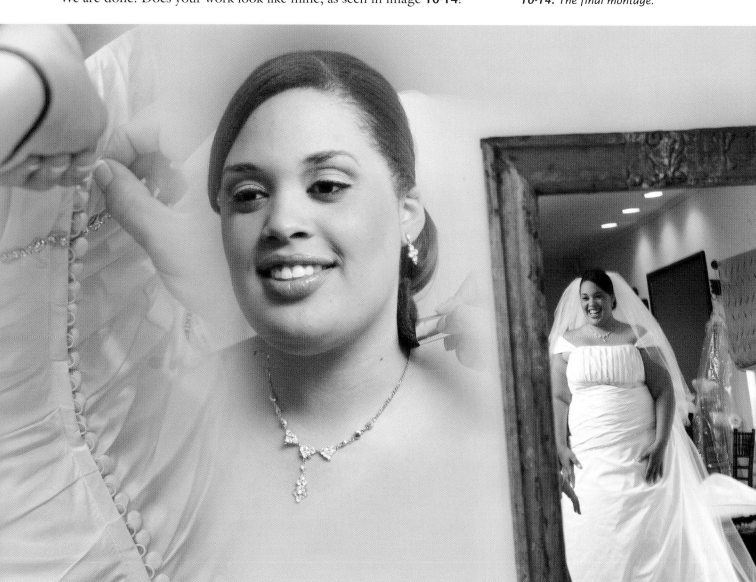

Conclusion

Now you have completed ten wedding album projects in varying levels of complexity. I hope they were as fun for you as they were for me. I love making albums because they allow me to elaborate creatively on the images. I look at my shots, then I bring them to a higher level. I am sure cows enjoy their regurgitation similarly! Pardon me for the analogy.

If you look around in our field of wedding photography, you will see thousands of generic-looking wedding albums. They do not stand out from the rest. In the digital-imaging era, it's easy for anyone to produce mediocre results—but being mediocre is not a winning strategy.

So, drop those templates, stop copying ideas, and be original. Make some albums that make brides gasp with joy. Now that you are armed with my secret weapons, you are ready to do just that.

Index